An Anthology
Arts and Crafts
Movement

isure &
re DUNDEE

An Anthology of the Arts and Crafts Movement

Writings by Ashbee, Lethaby, Gimson and their Contemporaries

EDITED BY MARY GREENSTED

Lund Humphries

First published in 2005 by

Lund Humphries
Gower House
Croft Road
Aldershot
Hampshire GU11 3HR

and

Suite 420
101 Cherry Street
Burlington
VT 05401-4405
USA

Lund Humphries is part of Ashgate Publishing

www.lundhumphries.com

An Anthology of the Arts and Crafts Movement
Writings by Ashbee, Lethaby, Gimson and their Contemporaries
© 2005 Mary Greensted

Mary Greensted has asserted her right under the Copyright, Designs
and Patents Act, 1988, to be identified as Author of this Work

British Library Cataloguing-in-Publication Data
A catalogue record for this book is available from the British Library

Library of Congress Control Number: 2005926250

Hardback ISBN 0 85331 920 0
Paperback ISBN 0 85331 923 5

Designed by Chrissie Charlton
Typeset by Tom Knott
Printed in England by TJ International

CONTENTS

FOREWORD

The Arts and Crafts Movement is difficult to define. Its impact was felt not only
in England, where it first developed, but in other parts of the British Isles, especially
Scotland and Ireland, many northern and Eastern European states, North America,
and British colonies worldwide. In 1905 T. J. Cobden-Sanderson, a practising artist-
craftsman and one of the leading figures in the early years of the Movement, high-
lighted its social objectives and its strong sense of vision in his book, *The Arts and
Crafts Movement:* what he and others called 'the art of life'. Many of the wide-ranging
and radical ideas which shaped the Movement in the second half of the nineteenth
century were a reaction against social, political and moral issues affecting Victorian
England. Advances in printing technology and the availability of cheap books spread
those ideas, as did the journals and magazines, societies and congresses set up as part
of the Movement. Some of these lectures and writings, such as *Arts and Crafts Essays*
by Members of the Arts and Crafts Exhibition Society (1893), have been reprinted
and are readily available; others have been quoted and referred to but are difficult
to find. It is on this latter group that I have concentrated in this anthology. I have
included some extracts from the lectures and writings of William Morris but not as
many as his importance warrants, because so much has been written about him and
his work and his writings and letters are readily available in published form and,
increasingly, on the Web.

Morris's passion for writing and speechmaking was taken up by the next
generation. Most Arts and Crafts writing reflects the complex nature of the Move-
ment. Useful handbooks providing historical background and practical instruction
were published alongside soul-stirring, powerful exhortations about art, life and
society. This complexity is reflected in the work of the three figures highlighted
in the title of this anthology. W. R. Lethaby (1857–1931) was an architect and
designer but above all a teacher, and his contribution to this book reflects his
importance as an educationalist. Ernest Gimson (1864–1919) has only one pub-
lished work to his name, an essay on plasterwork in *Plain Handicrafts* edited by
A. H. Mackmurdo (1851–1942) in 1892. According to Lethaby he believed that
art was *doing*, not designing, and writing about his work played an even smaller role
in his life. His unpublished writings, however, give revealing and intimate insights
into the realities of working as a designer and running a workshop. C. R. Ashbee's
(1863–1942) published works are wide-ranging, perceptive and persuasive. He had
a breadth of vision but placed his work and his Guild at the heart of all his writings.

I have also selected other original documents, letters, and journalistic writings to add depth and variety to the period. I have been fortunate to have had access to the archive resources at Cheltenham Art Gallery and Museum which have been a constant inspiration.

ACKNOWLEDGEMENTS

The original idea for this anthology came from Annette Carruthers. I am especially grateful for her initial ideas about the content and her helpful comments and suggestions. I would also like to thank Felicity Ashbee; Alan Crawford; Gavin Davies, Graham Gadd, Donald Gimson; Audrey Worgan; my colleagues at Cheltenham Art Gallery and Museum, especially Anna Stanway and Sophie Wilson; the staff at Gloucestershire Libraries, especially Roger Beacham, Jan Hexstall, Andrea Jones and Chrissie Tebbitt; Ray Leigh at the Gordon Russell Trust; Anna Sheppard and colleagues at the library of the Royal College of Art, London; the staff at both the National Art Library and the Archive of Art and Design, Victoria and Albert Museum; Amy Clarke and Peter Cormack at the William Morris Gallery, Walthamstow, London. Charles Greensted and Jo Comino provided expertise and moral support in the face of major computer meltdown. It has been a pleasure to work with Lund Humphries once again. In particular Lucy Myers made a number of valuable contributions to the structure of the anthology and Alison Green has provided helpful editorial guidance.

ABBREVIATIONS

CAGM	Cheltenham Art Gallery and Museum
EWG	Emery Walker Library at Cheltenham Art Gallery and Museum
RCA	Royal College of Art Archives, London
V&A AAD	Victoria and Albert Museum Archive of Art and Design, London
V&A NAL	National Art Library at the Victoria and Albert Museum, London
WMG	William Morris Gallery, London

LIST OF ILLUSTRATIONS

INTRODUCTION

The Arts and Crafts Movement emerged in a recognizable form in the 1880s. Frustrated by the exclusivity of the Royal Academy and the Institute of British Architects, a small group of 'workers in decorative design' [1] began meeting in each other's houses or studios to provide an opportunity for more fellowship and the exchange of ideas. The first meeting was held in the home of the writer and designer, Lewis F. Day. According to Walter Crane (1845–1915), designer, illustrator and committed socialist, the group had 'a happy if obscure life for several years'. [2] At the same time the St George's Society, set up by students from Norman Shaw's office, reputedly the most radical of the architectural offices in London, began regular meetings. These two loose groupings were formalized as the Art Workers' Guild. This society of designers, architects and craftsmen was founded in January 1884 with regular monthly meetings which included 'talks and demonstrations in various arts and crafts'.

The term 'Arts and Crafts' was coined some years later by T. J. Cobden-Sanderson (1840–1922), the bookbinder and founder of the Doves Bindery, when a name was being discussed for the Arts and Crafts Exhibition Society in 1887: alternative titles considered were 'The Combined Arts' or 'Associated Decorative Arts'. The Society was founded to introduce a more public and educational element to the work of Art Workers' Guild. Regular exhibitions would provide a showcase for good and useful design to educate and inspire the general public as well as to promote sales and commissions for exhibitors. From the start catalogues of essays and programmes of lectures were introduced alongside the exhibitions to reinforce the educational message. The first exhibition was held in the New Gallery in Regent Street, London in the autumn of 1888.

Stylistically the exhibitions were broad enough to show machine-made metal-work designed by W. A. S. Benson (1854–1924) alongside hand-raised pieces by C. R. Ashbee's Guild of Handicraft and exquisite jewellery and metalwork, using exotic materials and full of symbolic content, by Edward Spencer (1872–1938) and John Paul Cooper (1860–1933). Crane commented on the breadth of the Movement in terms of style:

> *The great advantage and charm of the Morrisian method is that it lends itself to either simplicity or to splendour. You might almost be plain enough to please Thoreau, with a rush-bottomed chair, piece of matting, and oaken trestle-table; or you might have gold and lustre (the choice ware of William*

de Morgan) gleaming from the sideboard, and jewelled light in your windows, and walls hung with rich arras tapestry. [3]

William Morris (1834–96), poet, designer, businessman and socialist, was the father figure of the movement. His lectures, published writings (many of his lectures were published in booklet form during his lifetime) and his practical work as a designer, businessman and retailer were an inspiration to the younger generation born in the 1850s and 60s. The committee meetings of the Society for the Protection of Ancient Buildings, founded by Morris in 1877, provided an opportunity for regular contact and exchange of ideas between Morris, his colleague Philip Webb (1831–1915), and young architects such as W. R. Lethaby and Ernest Gimson. Although his influence was inescapable, Morris kept himself somewhat detached from the movement, partly because of his commitment to political activity. He was not elected to the Art Workers' Guild until 1888 and only took part in the first Art and Crafts Exhibition after strong initial reservations. He did attend the meetings of the newly-formed National Association for the Advancement of Art and its Application to Industry in Liverpool in 1888 where the architect, John Dando Sedding (1838–91), expressed the feelings of many of his contemporaries:

> *The one man who above all others has inspired hope and brought life and light into modern manufactures is William Morris. And this because, a very giant in design, cultured at the feet of antiquity, learned in the history of art, rich in faith, prodigal of his strength, he has united in his own person the two factors of Industrial Art which before were divided – design and craftsmanship. Fancy what a year of grace it were for England if our industries were placed under the guiding hand of "one vast Morris." Fancy a Morris installed in every factory – the Joseph of every grinding Pharaoh. The battle of the industries were half won!* [4]

The other powerful source of inspiration, the artist and writer John Ruskin (1819–1900), was struggling with successive mental breakdowns in the 1880s and had retreated into semi isolation in the Lake District. He was described by Crane as 'an enormously vitalizing and still living force … The secret of his powers as a writer on art lies no doubt in the fact that he approached the whole question from the fundamental architectural side, and saw clearly the close connection of artistic development with social life.' [5] Morris referred to him as both 'my friend, Professor John Ruskin' and 'a great man', while on the subject of 'the arts giving us pleasure in our work' the chapter 'On the Nature of Gothic' in the second volume of *The Stones of Venice* was 'the truest and most eloquent words that can possibly be said'. [6] His writings remained required reading, although few of the younger generation were able to have first-hand contact with him.

Many of the themes which concerned the Arts and Crafts Movement from

the 1880s onwards had their roots earlier in the nineteenth century. Nature was promoted as the source for all pattern. Designers were encouraged to observe and draw from nature and to distil the essence of each form in their work. In 1849, the architect A. W. N. Pugin (1912–52) wrote about the role of nature in design in a similar vein:

> The present work originated in the following circumstances: – on visiting the studio of Mons. Durlet, the architect of Antwerp cathedral and designer of the new stall, I was exceedingly struck by the beauty of a capital cast in plaster, hanging among a variety of models, which appeared to be a fine work of the thirteenth century. On asking if he would allow me to have a squeeze from it, he readily consented, but at the same time informed me, to my great surprise, that the foliage of which it was composed had been gathered from his garden, and by him cast and adjusted in a geometrical form round a capital composed of pointed mouldings. This gave me an entirely new view of medieval carving; and, pursuing the subject, I became fully convinced the finest foliage work in Gothic buildings were all close approximations to nature and their peculiar character was chiefly owing to the manner of their arrangement and disposition. During the same journey I picked up a leaf of dried thistle form from a foreign ship unloading at Havre, and I have never seen a more beautiful specimen of what we should usually term Gothic foliage: the extremities of the leaves turned over so as to produce the alternate interior and exterior fibres, exactly as they are worked in carved pannels [sic] of the fifteenth century, or depicted in illuminated borders. The more carefully I examined the productions of the medieval artists, in glass painting, decorative sculpture, or metal work, the more fully I was convinced of their adherence to natural forms. [7]

This relationship between nature and Gothic design was emphasized by Ruskin while Sedding drew a parallel between the freshness of nature and the mid nineteenth-century Gothic Revival which had been

> ... a solid, and not a trifling, transient, piece of art-history. It has enriched the crafts by impetus and initiation. It has [imbued] two generations of art-workers with a new passion. It has been the health-giving spark – the ozone of modern art. In its train we get a whiff of the real, fresh, life-giving, south-west wind that has blown across the wide ocean of art since the morning of the world. [8]

This link with Gothic and medieval design was an impetus for the element of traditionalism, of learning from the past, which runs through the Arts and Crafts Movement. Sedding set the standard for many when he emphasized the importance of a living tradition:

> Suppose that I want to test the artistic quality of English art, of any date from the thirteenth to the fifteenth centuries, shall I consult the walls of the National Gallery for specimens of fine art

in easel pictures? If I did I should come empty away. Shall I not rather get me to some old
church of the first class, and find my answer in its every detail from floor to crest — in fretted roof,
carved boss, wall-decoration, screens, shrines, monuments, canopied stalls, metal-work, tapestries,
embroideries, glass windows, and so forth? Shall I not go to some old manor-house and consult its
fittings and design — in the stamped pattern on the lead water-butt, the moulding and ironwork
of the door, the plaister-frieze [sic], the tables, the chairs, the carved bedstead, with its embroidered
curtains and quilts, the panelled chest, the wainscot, the carved fireplace, the brass fireplace, the
andirons ... [9]

Crane also noted the influence of traditional crafts from the 1860s onwards,
particularly in the impact of pieces such as Morris and Company's 'Sussex' chair.

Enter to such an interior a plain unvarnished rush bottom chair from Buckinghamshire, sound in
wind and limb — "C'est impossible!" And yet the rush-bottomed chair and the printed cotton of
frank design and colour from an unpretending and somewhat inaccessible house in Queen Square
may be said to have routed the false ideals, vulgar smartness and stuffiness in domestic furniture
and decoration. [10]

A passion for traditional craftwork coloured the movement so that almost every Arts
and Crafts designer of furniture, from Ashbee to Gimson and C. R. Mackintosh
(1868–1928), produced versions of the traditional ladderback rush-seated chair.

The Arts and Crafts Movement was an attempt to raise design standards at every
level. Crane's vehement reaction to the debasement of design in the mid-nineteenth
century was shared by many of his contemporaries:

An illustrated catalogue of the 1851 exhibition will sufficiently indicate the monstrosities in
furniture and decoration which were supposed to be artistic. The last stage of decomposition had
been reached, and a period of, perhaps, unexampled hideousness in furniture, dress, and decoration
set in. [11]

In 1847, the enterprising civil servant Henry Cole set up Summerly's Art Manu-
factures to create links between art and manufacture. The project was short-lived
but commercially successful and the tradition did continue. Manufacturers such as
Henry Powell of James Powell and Sons, owners of the Whitefriars Glassworks, were
also Arts and Crafts enthusiasts while Arts and Crafts designers worked closely with
manufacturers. The long relationship between the pottery decorators Alfred and
Louise Powell and Wedgwood is a good example. Cole also set up a museum of
design after the Great Exhibition of 1851: The Museum of Ornamental Art, as it
was originally known, became the South Kensington Museum and then the Victoria
and Albert Museum. He also recognized the importance of design education and

the poor state of current provision – and this was an area where the Arts and Crafts Movement made a major and long lasting impact.

A number of contemporaries writing about Morris emphasized the importance of his first-hand experience of different techniques. According to Sedding, 'Morris has done more than the rest of us in regenerating art because he has not stopped at studio paper designs; but he put an apron on, tucked up his sleeves, and set to work.' [12] Morris continued this practical involvement in the crafts throughout his life (Fig.I).

Crane passed on the account of one of Morris's friends who called at the works, and, on enquiring for the master, hearing a strong cheery voice call out from some inner garden, 'I'm dyeing, I'm dyeing, I'm dyeing!' and the well-known robust figure of the craftsman presently appeared in his blue shirt-sleeves, his hands stained blue from the vat where he had been at work. [13]

Both Crane and Day [14] commented on the process by which Morris taught himself crafts such as tapestry weaving and then passed on the techniques to younger men such as J. H. Dearle. This became standard Arts and Crafts practice in work-shops throughout the country, in art schools and technical institutes, and through the range of technical handbooks produced as part of the Movement.

Morris himself and his firm, Morris, Marshall, Faulkner and Company, reconstituted as Morris and Company from 1875, provided an example for those wishing to combine art and business. The original prospectus of the firm founded in April 1861 emphasized the individual and artistic element in the project:

> *The growth of Decorative Art in this country owing to the effort of English Architects has now reached a point at which it seems desirable that artists of reputation should devote their time to it. Although no doubt particular instances of success may be cited, still it must be generally felt that attempts of this kind hitherto have been crude and fragmentary. Up to this time want of artistic supervision, which can alone bring about harmony between various parts of a successful work, has been increased by necessarily excessive outlay consequent on taking one individual artist from his pictorial labour.*
>
> *The artists whose names appear above hope by association to do away with this difficulty. Having among their number men of varied qualifications, they will be able to undertake any species of decoration, mural or otherwise, from pictures, properly so called, down to the consideration of the smallest work susceptible of art beauty. It is anticipated that by such co-operation, the largest amount of what is essentially the artist's work, along with his constant supervision, will be secured at the smallest possible expense, while the work must necessarily be of a much more complete order, than if any single artist were incidentally employed in this manner.*
>
> *These Artists having been for many years deeply attached to the study of the Decorative Arts of all time and countries, have felt more than most people the want of some one place, where they could either obtain or get produced work of a genuine and beautiful character. [. . .]*

It is only requisite to state further, that work of all the above classes will be estimated for and executed in a business-like manner; and it is believed that good decoration, involving rather the luxury of taste than the luxury of costliness, will be found to be much less expensive than is generally supposed. [15]

The explosion of population, industry, scientific enquiry and commerce which characterized Victorian Britain brought numerous social problems in its wake. By the 1880s the ebullient confidence which characterized the prosperous middle decades of the century was tinged with doubt. The writings of Thomas Carlyle (1795–1881) and the novels of Charles Dickens (1812–70) gave expression to popular concerns while political unrest was reflected in the doubling of trade union membership between 1888 and 1892. The impact of the Industrial Revolution on traditional ways of life in the English countryside was becoming painfully obvious. As early as 1871, in *Fors Clavigera*, John Ruskin argued for the redevelopment of rural industries. He set up the St George's Guild to put into practice his ideas for self-supporting communes combining manual labour with decorative work. In his book *The Minor Arts* (1880), the American writer Charles G. Leland promoted the establishment of technical classes in rural areas so that individuals could supplement their income from craftwork. His advice provided a source of inspiration for schemes such as the School and Guild of Handicraft set up by Ashbee in London's East End in 1888. A somewhat different approach was developed by Eglantyne Jebb who organized woodcarving classes for villagers on her husband's Shropshire estate in the 1870s. She saw the crafts not as an alternative source of employment for the working classes but as an antidote to 'idle hands' and as a tool to develop artistic appreciation and citizenship. Her Cottage Arts Association became absorbed into the London-based Home Arts and Industries Association in 1884. This non-professional element which runs through the Arts and Crafts had the effect of compromising the design element while broadening the impact of the movement.

The strong reformist element in the Arts and Crafts Movement provided the most challenging goals but gave it a lasting sense of purpose. In the Preface to the book of essays published as *Unto This Last*, Ruskin explained:

It was, therefore, the first object of these following papers to give an accurate and stable definition of wealth. Their second object was to show that the acquisition of wealth was finally possible only under certain moral conditions of society, of which quite the first was a belief in the existence, and even, for practical purposes, in the attainability of honesty. [16]

In many ways his thundering words could serve as an introduction to the Movement which he helped to shape:

It is, therefore, the manner and issue of consumption which are the real tests of production. Production does not consist in things laboriously made, but in things serviceably consumable; and the question for the nation is not how much labour it employs, but how much life it produces. For as consumption is the end and aim of production, so life is the end and aim of consumption. ... I desire ... to leave this one great fact clearly stated. THERE IS NO WEALTH BUT LIFE. Life, including all its powers of love, of joy, and of admiration. That country is the richest which nourishes the greatest number of noble and happy human beings; that man is richest who, having perfected the functions of his own life to the utmost, has also the widest helpful influence, both personal, and by means of his possessions, over the lives of others. [17]

Notes

1 Crane, W., 'The English Revival in Decorative Art', *William Morris to Whistler*, G. Bell & Sons, London 1911, p.59.
2 Ibid.
3 Ibid, pp 54–5.
4 Sedding, J. D., 'Things Amiss with our Arts and Industries', *Transactions*, National Association for the Advancement of Art and its Application to Industry, London, 1888, p.349.
5 Crane, W., p.51.
6 Morris, W., 'The Lesser Arts of Life', in Collected Works Vol.XXII edited by May Morris, Longman, Green & Co., London 1914, p.5.
7 Pugin, A. W., *Floriated Ornament*, Henry G. Bohn, London 1849, reprinted by Richard Dennis, Shepton Beauchamp, Somerset, 1994, unpaginated introduction.
8 Sedding, J. D., *Transactions*, p.354.
9 Ibid, p.351.
10 Crane, W., p.52.
11 Ibid, p.53.
12 Sedding, J. D., *Transactions*, p.355.
13 Crane, W., p.24.
14 Day, L. F., *The Art of William Morris*, Art Journal Easter Art Annual, London 1899.
15 Quoted by Poulson, C., *William Morris on Art and Design*, Sheffield 1996, pp 22–3.
16 Ruskin, J., *Unto This Last*, London, 1860, facsimile edition, Nelson, Lancs, 2000, pp xii–xiii.
17 Ibid, p.156.

CHAPTER ONE
THE DEVELOPMENT
OF THE MOVEMENT 1880–89

Introduction

The 1880s saw the formation of the Art Workers' Guild and the Arts and Crafts Exhibition Society, the main institutions associated with the Arts and Crafts Movement. Many of those involved in the establishment of these institutions set out and developed the philosophy of the Movement in print. This illustrates the role of ideas rather than style in the Arts and Crafts and also the polemic anti-establishment nature of many of the arguments. The writings in this decade established the breadth and principles of the Arts and Crafts and helped to inspire and recruit support for the Movement.

Commercial and design reasons persuaded William Morris of the need to develop the manufacturing capabilities of Morris and Company. He leased the Merton Abbey works outside London in June 1881 and Morris's colleague, the potter William De Morgan (1839–1917), found premises nearby.

The architect and designer Arthur Heygate Mackmurdo was the driving force behind the Century Guild, founded in 1882. Its aims – '... to render all branches of art the sphere no longer of the tradesman, but of the artist ...' [1] – were similar to those expressed in the 1861 prospectus of Morris's firm but its approach and achievements were different. There was a stronger avant-garde element, typified by the influential quarterly magazine *Hobby Horse* which was launched by members of the Guild in 1884 and combined modern painting and design with literature. The Guild was dissolved in 1888.

Social and political issues came to the fore in the 1880s. In 1883 Morris joined the Democratic Federation, which split off into the Socialist League in December 1884. The Home Arts and Industries Association, providing a central organization for amateur craft classes, was founded in the same year. In 1885 Canon Samuel Barnett (1844–1913) set up Toynbee Hall in London's East End as part of the University Extension Movement. It provided idealistic graduates from Oxford and Cambridge such as C. R. Ashbee with access to the local community, and his Guild and School of Handicraft, founded in 1888, was a direct result of his experiences.

'Almost everything and everybody had had their congresses and why not Art?' [2] In the 1880s many architects and designers, including Walter Crane who made this statement, worked tirelessly and co-operatively to ensure that art got its fair share of congresses, guilds and societies.

The Arts Workers' Guild was founded in 1884 bringing together two loose groupings: the St George's Society, made up of architects from Norman Shaw's office, and the Fifteen, designers and artists who had been meeting regularly to discuss topics of mutual interest. The Arts and Crafts Exhibition Society was a subsequent attempt by the Guild's membership to broaden its scope and its impact. Crane had feared that: 'The movement which I thought was to be a wide one will narrow itself to the action of a clique' [3] although one of the manufacturers approached to join, the society jeweller Carlo Guiliano, turned his back on the scheme because he feared it would end up 'no more or less than a Bazar' (sic). [4] Just as influential in its day was the National Society for the Advancement of Art and its Application to Industry which held meetings in Liverpool in 1888, and in Edinburgh the following year.

I.1 Lewis F. Day: General statements on design and ornament, 1882

Three extracts from *Every-day Art: short essays on the arts not fine* by Lewis F. Day, Batsford, London 1882

Lewis Foreman Day (1845–1910) was a prolific writer on design and ornament and a successful freelance designer of textiles, wallpaper, carpets, tiles and furniture (Fig.2). In 1881 he was appointed Art Director of the textile manufacturer, Turnbull and Stockdale. He played an active part in the early years of the Arts Workers' Guild and the Arts and Crafts Exhibition Society.

I.1.1 From 'Past and Present' in *Every-day Art* pp 36–7

> *Although each style of ancient art has its intrinsic merit, the value of any particular style is relative, and depends upon our immediate object in study ... Notwithstanding the beauty of a great deal of old work (and some of it is so perfect that the mere study of its details is a sort of education in itself), there is infinitely more to be learnt from the study of ancient processes than from the worship of antique forms. Half the charm of a design vanishes at once when we discover that it is only a reflection of something better that is past and dead. We grow tired of the continual repetition of the same beautiful but long since lifeless forms. On the contrary, our respect for the consummate art, the admirable tact, the masterly treatment of material, that we find in the best old work, can but increase with closer familiarity; here indeed we have something that is not only worthy of study, but capable of impregnating our work with no little of its own reality and manliness. [...]*
> *The good that modern decoration has derived from the accumulation of examples of ancient*

art around us in this generation, is out of all proportion small to what it should and would have been, if we had made intelligent use of them. Manufacturers reproduce at preposterous prices laborious copies of inexpensive oriental pottery, which is chiefly admirable for the ease and directness with which the artist potter produced so satisfactory a result; while they remain in contented ignorance of the secrets of the superiority of Eastern ware to the products of Stafford-shire. In spite of the influx of Japanese art among us, in spite of common-sense almost, they still hold the faith of the most ignorant amateurs that finish is only so much smoothness, that the highest art consists in the most minute elaboration. They think to imitate Etruscan terra-cotta by copying antique vase shapes, and printing upon them mechanical travesties of the bold and beautiful forms that flowed from the brush of the Greek so freely, that it is difficult to say exactly how much of the credit is due to the artist and how much to the brush. It is the same in almost everything. We copy the patterns of Persian carpets, while we somehow miss the charm of their colour. In all our modern Gothic furniture, where shall we find the simple but effective carving, clean, crisp, and vigorous, that enriched, almost as a matter of course, the common oak chests of two or three centuries ago? We should not dare to do so little to a panel as the old craftsmen felt to be enough.

I.I.2 From 'House and Home' in *Every-day Art* pp 174–5

Art does indeed cost something, but it is not the costly thing some would have us believe. It is as great a mistake to look upon it as ruinous extravagance as to think it can be had for the asking. The real costliness of decoration and furnishing is in doing what need not be done. Excess, elaboration, lavishness, are what cost most. Let there be no misunderstanding. Thoroughly good workmanship is always the best investment; it not only costs more, but is worth more than the showy manufacture made only to sell; what passes for ornament is very often introduced for the very purpose of concealing the evidence of scamping. In a perfectly plain piece of work a child can tell if the joints be inaccurate, the lines untrue, the surface unfinished. There are no flourishes to hide the faults. It is as if a clumsy penman should attempt to write in plain Roman character; the crookedness of his lines stares us in the face, naked; but, dressed up in flourishes, a very shaky letter will pass muster. Thus it happens that the simple, honest work costs rather more than that which is pretentiously florid. Good work minus art is, even commercially, worth more than poor work plus the cheap ornament that covers it; and, intrinsically, one piece of good craftsmanship is worth all the cheap ornament that was ever stuck on to something which was unsaleable without it. The cheapest furniture in the shops is that which is dear at any price. Next to that, for cheapness, comes the plain work which is good of its kind and without any kind of pretence. Then there is elaborate work, more or less worth what is asked for it; but the increased value as art is not at all in proportion to the increase in price, or even in proportion to the labour bestowed upon it. Every exhibition produces numbers of examples that illustrate at once what can be done, and what ought never to have been attempted in the way of ornament.

Simple work is more likely than elaborate to be worth its price. You seldom find good ornament in connection with flimsy construction. And yet excellence of construction must not be accepted as a guarantee of art.

I.I.3 From 'The Art of the Fashion-monger' in *Every-day Art* pp 154–6

Look at the jewellery we wear. There, if anywhere, is an opportunity for the exercise of refined and delicate appreciation of what is beautiful, for in most cases beauty is the only excuse for its existence. If we cannot afford to wear intrinsically beautiful trinketry, we can do very well without it. Not that there is any reason why it should be costly. The jewellery [5] *worn until recently by the peasant women of Normandy, Norway, Switzerland, and other European countries (now in imminent danger of being superseded by the attractions of more modern, showier, and altogether worthless Parisian and Viennese manufactures), was strictly peasant jewellery, the metal chiefly silver, and the stones garnets; but it was good work and well designed, worth transmitting from mother to daughter, and not fit only to be flung aside when the fashion had passed by. Men of discernment have been collecting and buying up the old examples of this work. Will any one be likely to buy up the remains of what is supplanting it? How much of this last will survive at all?*

There is this to be said of the better class of modern English goldsmith's work, that a certain honesty characterises it. It suggests "value received." But the value consists chiefly in the weight of the gold and in the bigness and rarity of the stones. This very character shows how little the artistic element of design is considered, or sought after, by those who lead the fashion. The Indian jeweller, according to Sir George Birdwood, [6] *thinks nothing of the intrinsic value of the precious stones he employs. He is an artist, and to him the value is in their colour, sheen, effect; he cares as much for them as a painter cares for his pigments, and no more. They are simply a means to his decorative end. The consequence is that he is able to use rich emeralds and rubies as lavishly as if they were enamel; and wherever he wants a point of light, bits of diamond are at hand, commercially of no great price, but artistically as useful as though they were priceless.*

Our English jewellery is just the reverse of all this. We must have fine and flawless stones, worth ever so much money, and masses of solid gold. We manufacture at a ruinous price heavy gold chains, that somehow will suggest fetters gilded; we embed rare stones in thick gold rings or other heavy and shapeless masses of metal, with a sort of idea that because all is plain it must be in good taste; we throw rare diamonds together in a glittering mass, which has none of the charm of colour characterising the gorgeous, but comparatively inexpensive, Eastern work. Art with us appears to decrease in proportion to the increased value of materials used. The greater the number of diamonds the more inevitably fashion rules that they shall be put together according to the principles that inspire the flaring illuminations which compel attention to the entrances of the London theatres.

1.2 The Century Guild (1882–8)

The Century Guild was founded in 1882 by A. H. Mackmurdo with fellow architect Herbert Horne (1864–1916), the stained-glass artist Selwyn Image (1849–1930), Clement Heaton (1861–1940) who specialised in metal and enamel work, and the sculptor Benjamin Creswick (1853–1946). According to a contemporary advertisement:

> By means of the co-operation of artists associated through the 'Century Guild', it is possible to maintain some sort of alliance between the arts when conjointly employed; thus putting stop to the battle of styles now raging between architecture and her handmaidens – a battle that mars by crude contrast of unrelated character the beauty and repose of our homes. [7]

The Guild worked with a number of manufacturers – such as the furniture makers Collinson and Lock and trade craftsmen – to produce their designs, but also in association with independent designers.

1.2.1 Advertisement for The Century Guild, 1882, from the archives of the William Morris Gallery, Walthamstow, London.

> *The Century Guild Work*
> *The Architects:*
> *Messrs. Mackmurdo & Horne, 28, Southampton St., Strand, W.C.*
>
> *Business Agents for Furniture and Decoration, Tapestries, Silks, Cretonnes, Wall Papers etc.:*
> *Messrs. Wilkinson & Son, 8, Old Bond St., W.*
> *Messrs. Goodall & Co., 15 & 17, King St., Manchester.*
>
> *Picture Frames designed by the Guild:*
> *Mr. Murcott, Framemaker, 6, Endell St., Long Acre, W.C.*
>
> *Wrought Iron Work:*
> *Mr. Winstanley, The Forge, Bush Hill Park, Enfield, N.*
>
> *Beaten and Chased Brass and Copper Work:*
> *Mr. Esling, at the agents of the Century Guild.*
>
> *In drawing attention to our own work, we have added, with their permission, the names of those workers in art whose aim seems to us most nearly to accord with the chief aim of*

this magazine. Our list at present is limited, but with time and care we hope to remedy this defect.

Embroidery:
The Royal School of Art Needlework, [8] *Exhibition Road, South Kensington, W.*
Miss May Morris [9] *gives private lessons in embroidery, particulars on application, Kelmscott House, Upper Mall, Hammersmith.*

Engraved Books and Facsimiles of the Works of Wm. Blake:
Mr Muir, the Blake Press, Edmonton.
To be had of Mr Quaritch, [10] *15, Piccadilly, W.*
During the present year, Mr. Muir hopes to publish engraved works from the designs of Mr. Herbert P. Horne.

Furniture and decoration:
Rhoda and Agnes Garrett, [11] *2, Gower St., W.C.*
J. Aldam Heaton, 27, Charlotte St., Bedford Sq., W.C.

Carpets, Silks, Velvets, Chintzes and Wall Papers, Embroidery, and Painted Glass:
Messrs. Morris & Company, 449, Oxford St., W.

Carving, and Modelling for Terra Cotta or Plaster Work:
Mr. B. Creswick, At the Agents of the Century Guild.

Designing and Engraving upon Wood:
Mr. W. H. Hooper, [12] *5, Hammersmith Terrace, W.*

Flint Glass, cut and blown, also Painted Glass:
Messrs. J. Powell & Sons, [13] *Whitefriars Glass Works, Temple St., E.C.*

Painted Glass, and Painting applied to Architecture and Furniture:
Mr. Selwyn Image, 51, Rathbone Place, W.C.

Painted Pottery and Tiles:
Mr. William De Morgan, [14] *45, Great Marlborough St., Regent St., W.*

Picture Frames:
Mr. Charles Rowley, [15] *St Ann's St., Manchester.*

Printing:
The Chiswick Press, [16] *21, Tooks Court, Chancery Lane, E.C.*

All Kinds of Wind Instruments:
Rudall, Rose, Carte & Co., 23, Berners St., W.

Reproduction of Pictures:
Photographs of Pictures by D. G. Rossetti,
To be had of Mr. W. M. Rossetti, 5, Endsleigh Gardens, N.W.

Platinotype Photographs from the Works of G. F. Watts, R.A., E. Burne-Jones, A.R.A., and others,
Mr. Hollyer, 9, Pembroke Square, Kensington, W.

Processes for Reproduction of Pictures and Drawings as used in this Magazine,
Messrs. Walker & Boutall, [17] *16, Clifford's Inn, Fleet St., E.C.*

I.3 The Arts and Crafts Exhibition Society (1888–1961)

Although it was founded in February 1887, the constitution of the Arts and Crafts Exhibition Society was formalised only after the opening of the first exhibition in October 1888. A meeting was held on 14 November 1888 to consider the draft constitution and draft rules and a committee was elected. The original members were W. A. S. Benson, [18] Somers Clarke, [19] Lewis F. Day, Mervyn Macartney, [20] William De Morgan, [21] William Morris, G. T. Robinson, [22] T. J. Cobden-Sanderson, Heywood Sumner, [23] Emery Walker, [24] Metford Warner, [25] and Stephen Webb [26] with Henry Longden [27] as Honorary Treasurer, Ernest Radford as Secretary, and Walter Crane as President. Works for exhibition would be chosen by a selection committee. Sales would be undertaken but the society would not charge any commission. It was also agreed that exhibitions should not be held for profit; any surplus would be put towards current expenses.

I.3.1 Extract from the Constitution of the Society, 1888, from AAD I/20-1980

Rules
The objects of the Society shall be to hold such Exhibitions of applied Design and Handicraft as from time to time shall seem desirable, and to arrange for the delivery of Lectures whereby the Worker may have an opportunity of demonstrating to the Public the Aptitudes and Limitations of his Craft.

Regulations
The name or names of the actual Designer and skilled Workman of every work intended for

Exhibition shall be supplied by the Exhibitor; but at the request of the Selection Committee the names of such other Executants as the Selection Committee considers to have contributed to its artistic production shall also be given. The names of the Designer and Executant or Executants shall be published in the Catalogue.

Membership
The Society shall consist of Artists and Craftsmen. None but those practically engaged in the Arts, either as Designers or actual Workers, shall be eligible as Members.

I.3.2 'Reports of the lectures at the Arts & Crafts Exhibition' by Oscar Wilde: extract from a review of Emery Walker's lecture on letterpress printing and illustration, *Pall Mall Gazette*, 16 November 1888

Oscar Wilde (1855–1900) began writing articles for the weekly *Pall Mall Gazette* from about 1885. In keeping with the paper's policy, the articles are unsigned but some pages survive among the ephemera in the Emery Walker Library [28] annotated in Walker's hand, 'written by Oscar Wilde'.

These lectures were seen by some of the members of the Arts and Crafts Exhibition Society, notably Cobden-Sanderson, as crucial to its work. He gave a talk on bookbinding a week later on 23 November, while Crane's closing lecture on 30 November was attended by 'such an enormous audience that at one time the honorary secretary became alarmed for the safety of the cartoons and many people were unable to gain admission at all. [29]

According to May Morris, [30] the images of finely proportioned type enlarged on the lantern slides excited Morris so that he persuaded Walker to help him design a new typeface. This was the Golden typeface completed in 1890.

NOTHING could have been better than Mr. Emery Walker's lecture on Letterpress Printing and Illustration, delivered last night at the Arts and Crafts. A series of most interesting specimens of old printed books and manuscripts was displayed on the screen by means of the magic-lantern, and Mr. Walker's explanations were as clear and simple as his suggestions were admirable. He began by explaining the different kinds of type and how they are made, and showed specimens of the old block-printing which preceded the movable type and is still used in China. He pointed out the intimate connection between printing and handwriting – as long as the latter was good the printers had a living model to go by, but when it decayed printing decayed also. He showed on the screen a page from Gutenberg's Bible (the first printed book, date about 1450–5) and a manuscript of Columella; a printed Livy of 1469, with the abbreviations of handwriting, and a manuscript of the History of Pompeius by Justin of 1451. The latter he regarded as an example of the beginning of the Roman type. The resemblance between the manuscripts and the printed books was most

curious and suggestive. He then showed a book printed at Venice, an edition of the same book [Cicero's Letters], the first by Nicholas Jansen 1470, and a wonderful manuscript Petrarch of the sixteenth century. He told the audience about Aldus, who was the first publisher to start cheap books, who dropped abbreviations and had his type cut by Francia pictor et aurifex, who was said to have taken it from Petrarch's handwriting. He exhibited a page of the copy-book of Vicentino the great Venetian writing-master, which was greeted with a spontaneous round of applause, and made some suggestions about improving modern copy-books and avoiding slanting writing.

A superb Plautus printed at Florence in 1514 for Lorenzo di Medici, Polydore Virgil's History with the fine Holbein designs, printed at Basle in 1556, and other interesting books, were also exhibited on the screen, the size, of course, being very much enlarged. He spoke of Elzevir in the seventeenth century when handwriting began to fall off, and of the English printer Caslon, and of Baskerville, whose type was possibly designed by Hogarth, but is not very good. Latin, he remarked, was a better language to print than English, as the tails of letters did not so often fall below the line. The wide spacing between lines, occasioned by the use of a lead, he pointed out, left the page in stripes and made the blanks as important as the lines. Margins should, of course, be wide except the inner margins, and the headlines often robbed the page of its beauty of design. The type used by the Pall Mall was, we are glad to say, rightly approved of.

With regard to illustration, the essential thing, Mr. Walker said, is to have harmony between the type and the decoration. He pleaded for true book ornament, as opposed to the silly habit of putting pictures where they are not wanted, and pointed out that mechanical harmony and artistic harmony went hand in hand. No ornament or illustration should be used in a book which cannot be printed in the same way as the type. For his warnings he produced Rogers's Italy with a steel-plate engraving, and a page from an American magazine which being florid, pictorial and bad, was greeted with some laughter. For examples we had a lovely Boccaccio printed at Ulm, and a page out of La Mer des Histoires printed in 1488. Blake and Bewick were also shown, and a page of music designed by Mr. Horne.

The lecture was listened to with great attention by a large audience, and was certainly most attractive. Mr. Walker has the keen artistic instinct that comes of actually working in the art of which he spoke. His remarks about the pictorial character of modern illustration were well timed, and we hope that some of the publishers in the audience will take them to heart.

I.4 The National Association for the Advancement of Art and its Application to Industry (1888–91)

Six extracts from *Transactions of the National Association for the Advancement of Art and its Application to Industry*, Liverpool meeting, London, 1888.

The first meeting of this association, founded in 1887 to give manufacturers 'some better understanding of the relation of industry to life', [31] was held in Liverpool in

December 1888. Two further meetings were held in Edinburgh and Birmingham. The scope of the lectures and the interest of the audience were broad:

> The royal academician sat down with the socialist; the scientific colour theorist fed with the practical decorator; the industrial villager faced the manufacturer; the art critic and the painter mingled their tears and all were led to the pasture by a gentle Fine Art professor. [32]

The meeting was divided into sections covering painting, sculpture, architecture, applied art, museums and national and municipal encouragement of art. Sir Frederic Leighton (1830–96) was the overall President with Walter Crane, President of the applied art section. Gillian Naylor emphasizes the 'radicalism, prescience and the sound common sense of many of the proposals. [33]

I.4.I Objects of the Association, *Transactions* p.viii

> The Association has been formed for the purpose of holding an Annual Congress in the principal manufacturing towns in the Kingdom, in rotation, to discuss problems of a practical nature connected with the welfare of the Arts, Fine and Applied. . . .
>
> It is widely felt in the great manufacturing centres — and the feeling has found expression in Liverpool — that the present conditions both of Art and Industry, offer many problems which stand in pressing need of discussion. Machinery, by making less immediate the contact of the artizan with the object of manufacture, and by its tendency to specialise the artizan's work, has rendered obsolete, so far as many industries are concerned, the old traditions of design, and these have not as yet been replaced by new. Machinery has, moreover, been suffered to annihilate many minor handicrafts, the place of which has not been supplied in any adequate fashion. The adaption therefore of artistic design to modern methods of manufacture, and the cherishing, or rehabilitation, of many crafts which are independent of machinery, and in which the individuality of the workman's touch is an essential feature, are matters of high importance at the present time.
>
> The welfare of the masses of our people largely depends upon the commercial superiority of England. That commercial superiority cannot be maintained by the fact of bygone priority or exclusive possession of labour-saving inventions. In the face of hostile tariffs and narrowing margins of profit all over the world, it is by excellence of make and superiority of artistic design that the products of manufacture of any country will henceforth attain prestige and command markets. But the artistic quality of a nation's manufactures, and its prosperity through the Applied Arts, depends upon its high level of excellence in the Fine Arts. The education of artists and artizans, the maintenance and development of museums of all kinds, the steps taken to elevate the taste of the people, the amount and intimacy of the contact between higher and lower orders of artists and craftsmen, the encouragement which governments and municipalities, in the mere exercise of their ordinary functions, may be able to give to the forces of artistic production — these, and like

questions, are thus involved in the industrial problems placed before us by the inexorable progress of events.

The demand for pictures, which has existed for some half-century past, tends apparently to decrease. The magnitude and long continuance of that demand have produced an over-supply of painters, an increasing number of whom will be forced into the ranks of the unemployed, unless they consider their position betimes, and discover new areas for the exercise of their skill. Changed conditions are involving the overthrow and re-erection of large parts of our hastily built towns. Architects have thus an opportunity before them, of which they can only take full advantage, if they call in the help of craftsmen trained in the schools of Painting, Sculpture, and the Decorative Arts.

I.4.2 From the Presidential Address to the Applied Art Section by Walter Crane, *Transactions* pp 206, 209, 211–12, 216

We are here to further the Advancement of Art in its Application to Industry. Are we quite sure that we do not mean the advancement of industry by the application of art? [...]

I have constantly been struck in passing through one of our industrial exhibitions — those huge trophies of the world's trade, that we have raised from time to time, and which are counted among the triumphs of the century — I have often been struck with the marvellous mechanical invention, and the extent and range of the application of steam machinery, and one is impressed with a vivid idea of the lightning speed with which the competitive race is run, and the scale on which the world's market is stocked. But if one enquires how this mechanical march has affected the progress of art, the answer generally appears in some such shape as this. We may perhaps see some wonderful piece of ingenuity and mechanism — a carpet loom, for instance, such as I saw at the American Exhibition in London. The machine itself appeared to be a marvel of adaptation; but it would seem as if all the invention had been exhausted upon the means of production, and when one came to the product itself — the carpet in the loom — the result as an artistic matter, a matter of design and colour, was simply deplorable. So that one generally turns from these triumphs of the century with a conviction that we have lost sight of the end in our search for mechanical perfection in the means. [...]

When the power of reproduction is so enormous, it becomes, obviously, more than ever necessary to reproduce nothing in design but what is sound and good in its own way. If not, far better confine ourselves to the manufacture of plain materials: good cloth, well woven and dyed, without pattern; serviceable furniture, without carving or painting, unless it can be sincere and thoughtful; useful pottery, as good in contour as the wheel and the skill of the thrower can make it, unspoiled by the ravings of the china painter distracted by centuries of false taste, or confused by dictionaries of ornament, or the impressionism of the modern Japanese or Parisian. [...]

The real secret of Continental influence in design upon us is no doubt to be found in the

fact that the severance of the arts and handicrafts has never been anything like so complete in other European countries as in industrial England. . . . However degraded the taste of the designer, or debased in type the design, the Frenchman or the Italian designer remained thoroughly in touch with the craftsman, and understood the technical conditions of the work thoroughly so that his working drawings would be perfectly adapted to the method of manufacture. We have here, at any rate, one reason why our manufacturers have given preference to French designs, and have been so much in the habit of crossing the water for new supplies. [. . .]

At the preliminary meeting for the formation of this Association, held in London, in the summer, I took occasion to say that, "We must turn our artists into craftsmen, and our craftsmen into artists." That is the problem before us in the matter of art and industry. [. . .]

Make a man responsible, and give him the credit of his own skill in his work: his self-respect at once increases, and he is stimulated to do his best; he will take pride and pleasure in his work; it becomes personal and therefore interesting.

I.4.3 From 'Art and its Producers' by William Morris, *Transactions* p.228

Whereas the incentive to labour is usually assumed to be the necessity of earning a livelihood, and whereas in our modern society this is really the only incentive amongst those of the working-class who produce wares of which some form of art is supposed to form a part, it is impossible that men working in this manner should produce genuine works of art. Therefore it is desirable either that all pretence to art should be abandoned in the wares so made, and that art should be restricted to matters which have no other function to perform except their existence as works of art, such as pictures, sculpture, and the like; or else, that to the incentive of necessity to labour should be added the incentives of pleasure and interest in the work itself.

I.4.4 From 'The Home Arts Movement' by W. E. Willink ARIBA, *Transactions* pp 271–2, 273

It will have been noticed that there are no less than three papers [34] *to be read in this Section today touching upon the work to which I have given the general title of the Home Arts Movement. It is no doubt not by accident but by design that the subject has had such a prominent place allotted to it in the list of matters to be discussed. I allow myself to believe that it was so placed owing to a feeling that what refers to the ground and basis of the work set before itself by this National Association ought to have early consideration. And that is really the position of the Home Arts Movement which aims at spreading among the mass of the people, at making the common property of the whole nation, a priceless possession which has hitherto been enjoyed only by the small proportion, commonly termed cultured, of the small minority known as the upper classes. [. . .]*

The work is, and has been, carried on by two sorts of classes: those founded and assisted by

the Home Arts and Industries Association, the operations of which are extended all over the United Kingdom, and a number of isolated classes unconnected with this body. . . . And as the chief reason for the existence of this association in its present form is its power of starting and fostering new classes in places where the necessary impetus, knowledge, and originality are wanting, I feel that it is quite possible that where independent classes are formed they may for a time do even better work than those affiliated to the society. It is, therefore, with no feeling of disparagement towards the isolated classes, but only with a regret that it is impossible to retain all the advantages of incompatible methods, that I venture to assert that the ultimate success of the whole movement lies with the association. It is only by its organization that it is possible to make sure of a universally high standard of design and work, to compare results for the encouragement of members and the information of those outside, and to give such guarantees as will justify people in general, public or private, in supporting work for which they are not themselves responsible. [. . .]

The work of the classes themselves, affiliated or independent, is identical. They are held in the evenings, or on Saturday afternoons, intervals of leisure in the laborious lives of artisans and labourers, when voluntary teachers give instruction in various arts and handicrafts, such as drawing, modelling, wood carving, brass beating, embossed leather and mosaic. Instruction is given at the same time in the principles of design and in actual execution. More idea will be gained of the work done, and of the principles which govern it, by an examination of the objects which have been kindly lent to me than I could give by a long explanation.

One fundamental characteristic of the work must be noticed, and that is the double nature of the end set before them by its founders. The association was founded, and individual classes are generally opened, quite as much with the object of benefiting the pupils in their morals and life as with teaching them art.

I.4.5 From 'Economic Arguments for the Encouragement of the Fine Arts'
by Professor Patrick Geddes, *Transactions* p.335

It is specially the duty of our section [35] to bring the claims of the artist before the public, but also the claims of the public before the artist. For we cannot too clearly realise at the outset that the amount of national and municipal encouragement of art does and must, nay should, accurately depend on what art is able and willing to do for the nation and the municipality. [. . .]

Our business is mainly with those newer artists among us — happily a majority here — who point us, first, to the sorry case of actual Labour in the vast modern city which he has builded practically without aid from art, and whom they now seek to rouse from this lethargy, and this not merely to upbraid. They tell him that this Art, which is now loudly knocking at his door, is neither a beggar, nor a goddess, but his very housemate and helpmeet of old — separated, indeed, for a time by evil chance and mutual folly, but whose return will refresh his whole life and labour, and transform his gloomy labyrinth anew into a home worthier and fitter for his children.

From 'Things Amiss with our Arts and Industries' by John D. Sedding,
Transactions pp 343, 344–5, 348–9

Whatever else may be said about it, this National Association for the Advancement of Art and its Application to Industry is a novelty in the history of civilization. [...]

We are here not to speak smooth things of the art of the individual that splendidly succeeds, but the rough truth about general art that lamentably fails. Something is readily amiss with our arts and industries that baulks our high intent, that renders our best efforts barren, and robs us, one and all, of art's honest reward in satisfaction for well-directed toil. [...]

Machinery, we are told, has broken up the old traditions of design and manufacture. Machinery has disturbed the contact between artizan and the object of manufacture; it has checked the handicrafts by specialising the different phases of the craftsmen's labours; it has originated other standards of work, has curtailed the number, and warped the scope, of time-honoured industries. [...]

The harm that has come to our manufacturers through machinery is undeniable, yet let us not be too hard upon the machine, which, after all, has no volition of its own, but is merely a dead passive instrument of mechanism.... To deplore the bad design of our manufactures is one thing, but there is something to deplore still more, that is, the bad design of the manufacturer, who, eager for his margin of profits, has regarded neither the interests of art nor of trade morality, nor the interests of the operatives by whose labours he became rich.

The problem of our industries has two sides – an art side, and a social side; it relates to bad art, and it relates to the bad social condition of the dwellers in those congeries of buildings known as manufacturing towns. And if the evil be two-fold the remedy must be two-fold – we may not apply an art-remedy and leave the social maladies uncured. It were to no purpose that you take steps to elevate the taste of the people, as is suggested by planting picture-galleries and museums in our manufacturing towns, while you leave these towns in outward appearance and social condition as they are now. To put the matter simply, our industries suffer the curse of three evils – bad design, bad materials and the miserable life and surroundings of the operatives There was a time when neither manufactures or nor manufacturers were open to reproach, and yet the machine was then in use. There was a time when the atmosphere of English commerce was pure – when sham and shoddy were not the vogue – when the manufacturer was not a mere financing capitalist, but a man among his men, before "the lust of gain in the spirit of Cain" was rampant in the land. [...]

... the Act will come someday that will right the wrongs of our industries by organizing some wisely regulated scheme of co-operation, or some systematic profit-sharing The problem of the social condition of the industrial classes must be met and faced.... That things cannot long stand as they are is certain, and if the mending of wrongs doesn't come from the masters, it will – as with the wages and hours of labour questions – come from the men.... In time some amelioration will result from the gifts of public parks, libraries, beautiful churches ... from improved artizans' dwellings, from the encouragement of the home arts in schools and villages.... As to the continued use of machinery, in spite of the mischief that has been laid to its charge, manufacture cannot be

organized upon the basis of no machinery. We had better understand this, and make life square with facts, rather than rebel against the actual in striving for the ideal.

As to further remedies. Our manufactures must be of good material and make. The designs must, moreover, be good and well adapted to the necessities of modern methods of production. It is not enough, however, to get good designs, but the man who made the design must be at hand at its manufacture. The competent designer must become part of the permanent staff of our factories so that he may see his design grow, and be consulted as required. We have had enough of studio designs. Technical schools do great good, but the good they do is limited. The best school for art industry is a wholesome factory. The ideal factory is a place where the artist-designer is workman, and where the workman is an artist in his way.

I.4.7 From 'The Arts and Crafts of Today' by William Morris, 1889, reprinted in *Collected Works* Vol.XXII edited by May Morris, Longman, Green & Co., London 1914, pp 359, 366–8

This lecture was first given to the second meeting of the National Association for the Advancement of Art and its Application to Industry in Edinburgh.

Well now, I say, that as eating would be dull work without appetite, or the pleasure of eating, so is the production of utilities dull work without art, or the pleasure of production; and that is Nature herself who leads us to desire this pleasure, this sweetening of our daily toil ...

Indeed I began by saying that it was natural and reasonable for man to ornament his mere useful wares & not to be content with mere utilitarianism; but of course I assumed that the ornament was real, that it did not miss its mark, and become no ornament. For this is what makeshift art means, and that is indeed a waste of labour.

Try to understand what I mean: you want a ewer and a basin, say: you go into a shop and buy one; you probably will not buy a merely white one; you will scarcely see a merely white set. Well, you look at several, and one interests you about as much as another: that is, not at all; and at last in mere weariness you say, "Well, that will do"; and you have your crockery with a scrawl of fern leaves and convolvulus over it which is its 'ornament'. The said ornament gives you no pleasure, still less any idea; it only gives you an impression (a mighty dull one) of bedroom. The ewer also has some perverse stupidity about its handle which also says bedroom, and adds respectable: and in short you endure the said ornament except perhaps when you are bilious and uncomfortable in health. You think, if you think at all, that the said ornament has wholly missed its mark. And yet that isn't so; that ornament, that special form which the ineptitude of the fern scrawl and the idiocy of the handle has taken, has sold so many dozen or gross more of that toilet set than of others, and that is what it is put there for; not to amuse you, you know it is not art, but you don't know that it is trade finish, exceedingly useful ... to everybody except its user and its actual maker.

But does it serve no purpose except to the manufacturer, shipper, agent, shopkeeper, etc.? Ugly, inept, stupid, as it is, I cannot quite say that. For if, as the saying goes, hypocrisy is the homage which vice pays to virtue, so this degraded piece of trade finish is the homage which commerce pays to art. It is a token that art was once applied to ornamenting utilities, for the pleasure of their makers and their users.

Now that we have seen that this applied art is worth cultivating and, indeed that we are here to cultivate it; but it is clear that, under the conditions above spoken of, its cultivation will be at least difficult. For the present conditions of life in which the application of art to utilities is made imply that a very serious change has taken place since those works of cooperative art were produced in the Middle Ages, which few people I think sufficiently estimate.

Briefly speaking, this change amounts to this, that Tradition has transferred itself from art, to commerce ... that commerce which has now embraced the old occupation of war, as well as the production of wares. But the end proposed by commerce is the creation of a market-demand, and the satisfaction of it when created for the sake of the production of individual profits: whereas the end proposed by art applied to utilities, that is the production of the days before commerce, was the satisfaction of the genuine spontaneous needs of the public, and the earning of individual livelihood by the producers. I beg you to consider these two ideas of production and you will see how wide apart they are from one another. To the commercial producer the actual wares are nothing; their adventures in the market are everything. To the artist the wares are everything; his market he need not trouble himself about; for he is asked by other artists to do what he does do, what his capacity urges him to do.

Notes

1 Quoted in Naylor, G. *The Arts and Crafts Movement*, London 1971, p.117.
2 Crane, W. 'The English Revival in Decorative Art' in *William Morris to Whistler*, London 1911, p.73.
3 Letter to W. A. S. Benson, dated 23 February 1887, AAD 1/8-1980.
4 Letter to J. Hungerford Pollen, dated 21 April 1887, AAD 1/12-1980.
5 May Morris (1862–1938), daughter of William Morris, had a collection of European peasant jewellery which influenced her jewellery designs from the end of the nineteenth century.
6 Sir George Birdwood (1832–1917) devoted much of his life to cataloguing and promoting traditional crafts in India. His work was praised by William Morris in his lecture 'The Art of the People', 1879. Morris wrote: 'In some parts of the country the genuine arts are quite destroyed; in many others nearly so; in all they have more or less begun to sicken. So much so is this the case, that now for some time the Government has been furthering this deterioration. As for example, no doubt with the best intentions, and certainly in full sympathy with the general English public, both at home and in India, the Government is now manufacturing cheap Indian carpets in the Indian gaols. I do not say that it is a bad thing to turn out real work, or works of art, in gaols; on the contrary, I think it good if it be properly managed. But in this case, the Government, being, as I said, in full sympathy with the English public, has determined that it will make its wares cheap, whether it make them nasty or not.' *William Morris Collected Works* Vol.XXII edited by May Morris, London 1914, p.37.
7 Quoted by Lambourne, L. in *Utopian Craftsmen*, Astragal Books, London 1980, p.40.
8 The Royal School of Art Needlework was founded in 1872 to revive ornamental needlework and to provide employment for gentlewomen.
9 May Morris, the younger daughter of William Morris, designed embroideries and jewellery.
10 Bernard Quaritch (1819–99) also issued and distributed many of William Morris's books.
11 Rhoda and Agnes Garrett were cousins who set up as interior decorators in London in the 1870s.

12 W. H. Hooper (1834–1912) did much of the wood engraving for William Morris and the Kelmscott Press.

13 James Powell and Sons were established glass manufacturers who were in sympathy with Arts and Crafts philosophy.

14 William De Morgan's pottery was sold both by the Century Guild and Morris and Company.

15 Charles Rowley (1840–1933) was also a socialist and philanthropist.

16 The Chiswick Press, a long-established family business, developed a close working relationship with Morris and the Arts and Crafts Movement.

17 Walker and Boutall was the firm of process engravers set up by Emery Walker with Walter Boutall in 1885.

18 W. A. S. Benson was a designer whose light fittings were used in Morris and Company interiors. Although his metalwork was turned or cast by machine, this did not exclude him from the Arts and Crafts community.

19 G. Somers Clarke (1841–1926) was an architect whose articles on 'Stone and Wood Carving', 'Stained Glass', and 'Table Glass' were published in *Arts and Crafts Essays*, 1893.

20 Mervyn Macartney (1853–1932) was an architect and designer. He was editor of *Architectural Review* from 1905–20.

21 William De Morgan designed stained glass, tiles and pottery. He experimented with kilns and rediscovered techniques for lustre glazes.

22 G. T. Robinson (1828–97) was a designer specializing in wallpaper, plasterwork, and sgraffito.

23 G. Heywood Sumner (1853–1940) was an artist, illustrator, and designer. He is best known for his experiments with sgraffito.

24 Emery Walker (1851–1933) was a process engraver who worked closely with Morris in founding the Kelmscott Press. He subsequently founded the Doves Press with Cobden-Sanderson.

25 Metford Warner was the director of the wallpaper firm, Jeffrey and Company.

26 Stephen Webb (1849–1933) designed furniture for Collinson and Lock, specialising in intarsia or inlaid work in ivory, and designed wallpaper for Jeffrey and Company. He later taught sculpture at the Royal College of Art.

27 Henry Longden was a cast iron manufacturer from Sheffield. He had been introduced to the Art Workers' Guild by Sedding whose architectural office was above Longden's London premises at 447 Oxford Street, next door to Morris and Company.

28 Emery Walker Library, CAGM, 1991.1016.163.

29 Ibid.

30 Morris, M. (ed.) *William Morris, Collected Works*, Longman, Green & Co., London 1912, Vol.XV, p.xv.

31 A. H. Mackmurdo quoted in Naylor, G. *The Arts and Crafts Movement*, Studio Vista, London 1971, p.160.

32 Crane, W. 'The English Revival in Decorative Art', *William Morris to Whistler*, London 1911, p.74.

33 Naylor ibid. p.161.

34 The Applied Art section also included the Rev. H. H. Rawnsley on 'Country Industrial Schools: their Aims, Claims and Needs' and H. B. Bare on 'A School for Artistic Handicrafts'.

35 This paper was given as part of the section on National and Municipal Encouragement of Art.

CHAPTER TWO
THE MOVEMENT TAKES SHAPE 1890–99

Introduction

The 1890s saw many of the ideas developed in the previous decade take shape. Workshops and guilds inspired by Arts and Crafts ideals were set up in London and other cities; amateur groups flourished in towns and villages. Arts and Crafts principles infiltrated colleges and technical institutes and began their long-lasting influence on the teaching of art and craft. Much of the published material during this period was practical in character, providing inspiration and information for this rapidly expanding market (Fig.3).

In 1890 the Guild of Handicraft (Fig.4) moved to larger premises – Essex House, a Georgian house in the Mile End Road – and at the same time opened a West End retail outlet at 16a Brook Street. The success of the enterprise was signalled by the commission to carry out M. H. Baillie Scott's (1865–1945) designs for the Ducal Palace at Darmstadt in 1897.

The short-lived furniture making enterprise, Kenton and Company, was set up at the end of 1890. After it closed two of the participants, Ernest Gimson and Sidney Barnsley (1865–1926), rejected traditional careers as architects in favour of a new country-based enterprise together with Sidney's elder brother, Ernest Barnsley. The three men moved to the Cotswolds in spring 1893. Rural Arts and Crafts activity flourished: Godfrey Blount (1857–1922) setting up the Haslemere Peasant Industries in 1896, the Langdale Linen Industry expanded and Arthur Simpson's (1857–1922) workshops were established in the Lake District.

Education was a central theme throughout the Arts and Crafts Movement, and 1896 saw the establishment of the influential LCC Central School of Arts and Crafts with W. R. Lethaby appointed as one of the joint principals. Similar developments were set up in other urban centres such as the Vittoria Street School for Silversmiths and Jewellers in Birmingham and the Keswick School of Industrial Art. At the same time established manufacturers, such as Arthur Lasenby Liberty (1843–1917), saw commercial advantages in adopting Arts and Crafts designs. He set up the Cymric range of metalwork which was sold in his Regent Street store in 1899.

A new magazine, The Studio, first published in 1893 under the editorship of W. Gleeson White (1851–98) became recognised as the mouthpiece of the movement. Two young architect-designers, Baillie Scott and C. F. A. Voysey (1857–1941),

were nurtured by the magazine and their work reached a wide international audience. Numerous handbooks and magazines were also published providing source material and technical information to assist and encourage the growing body of students and amateurs interested in design and craftwork.

William Morris founded the Kelmscott Press in 1890, paving the way for the twentieth-century revival of the private press movement. After Morris's death in 1896 Ashbee set up the Essex House Press, buying two of the Kelmscott Albion presses and employing some of the workforce.

2.1 From *Art and Handicraft* by John D. Sedding, 1893

Art and Handicraft was a collection of lectures and writings by Sedding, collected together and published two years after his death at the age of 53. 'The Handicrafts in Old Days' was a lecture delivered to the Whitechapel Guild of Crafts in January 1890. This Guild was set up by Hubert Llewellyn Smith (1864–1945), an Oxford graduate with links to Toynbee Hall and a one-time friend and colleague of C. R. Ashbee in the early days of the School and Guild of Handicraft. Sedding had been invited to talk to the guild 'about *craft*, the *art* will come late on'. [1] He welcomed the opportunity because of the close connection between architects and the handicrafts and because, as he put it:

> *Artists are gregarious folk; they herd together ... If the artist paint a picture, carve a panel, make a book-case, model a plaster-frieze, it is done, not simply for his own pleasure, but for the pleasure others share with him. He must have an appreciative public to work* for, *and fellows like-minded with himself to work* with. [2]

He encouraged his audience to eschew museum collections and instead to study old buildings: 'an old English house or church was ... the garden of the arts and crafts'. He continued:

> *We hear ... too much of the "Applied Arts", which is a new-fangled term, covering a new-fangled class of art-workmanship, to suit the gentlemen-draughtsmen turned out of the Kensington Schools ... This chatter about the "Applied Arts"... encourages the fatal notion that art is a thing to be "applied" – that is a dispensible commodity, not an integral part of all work, of all manufacture whatsoever.* [3]

Sedding emphasised the balance between beauty and use, the unity between the work and its setting achieved by the use of local materials and traditions, and the absence of self-conscious cleverness:

It was left to the modern quack to advertise with all the emphasis of capital letters: "Artistic Furniture, Unrivalled in Style, Perfection of Workmanship, and Originality of Design." Indeed I can quite believe that the production of a whole roomful of old furniture did not require anything like the violent effort, the rending of joints and marrow, the agony of invention that one trumpery Tottenham Court Road wooden coal-scuttle called forth, that is fribbled all over with brummagem brass strips and painted spring flowers (poor things) the whole concern "Too foolish for a tear, too wicked for a smile." [4]

2.1.1 From 'The Handicrafts in Old Days' from *Art and Handicraft*, Kegan Paul, London 1893, pp 80–1

If, then, we are to expect to benefit to current or future art by our efforts at self-improvement, we must not stop at mere ornament. If we want to produce a nice chest of drawers — say — we must begin at the bare boards, and not at the surface ornament. Nay, perhaps the most valuable lesson of all, to learn, is that it is not prettiness that endues a thing with highest charm, but character. A striking proof of this is Mr. Madox Brown's delightful deal "Workman's chest of drawers and glass," at the Arts and Crafts Exhibition the other day — quite a plain thing with only a jolly, depressed carved shell above the glass and chamfered to the edges of the drawers — made in deal and stained green — that is all! It was just a commonplace thing handled imaginatively, and it gave me as much pleasure as anything in the exhibition. It made me feel that it takes a big man to do a simple thing: for the big artist takes broad views, he gives use its proportionate place, he knows the virtue of restraint, and he has character to impart.

I say that a builder's yard — take things all round — is the very best and most wholesome place to learn general handicraft — all about form, texture, composition. For this reason, nothing in the world would serve your craft-school so well as for some good rich man from the West-End to come here and say, "I have found you a site, and I've paid for the materials, and the tools, and I've got a capable 'ganger' for each trade, — now, go you and build yourselves a home for your school, or a noble church for your parish." If this good luck befell you, I can safely declare that your building would only be good as you aimed at the virtues exhibited in the handicrafts of old days that I have been prosing about. In the meantime work on, in a smaller way, cherishing a high ideal of handicraft, remembering what Michel Angelo said — "Nothing makes the soul so pure, so religious, as the endeavour to create something perfect: for God is perfection: and whoever strives for perfection, strives for something that is God-like."

Work on! be of good cheer, times must be mending or you would not be here. Be yourselves in your work, express what you have to say in your nineteenth-century fashion. Carry your crafts home: we have seen what quiet joy the handicrafts could give in old days, when art was a dear and genuine inmate of home: take your crafts home, let them make your home homelier, family-life brighter. Art is "happy-making:" and, after religion, there is nothing in this world that is so well calculated to diffuse delight, to sweeten toil, and to lead men's thoughts along pleasant grooves, as the old handicrafts of Merry England.

2.2 The Guild of Handicraft in London's East End (1888–1902)

C. R. Ashbee described the origins of the Guild and School of Handicraft in 1886–7 in *Transactions*, published in 1890. As an architectural student working in the London office of J. F. Bodley, Ashbee moved into Toynbee Hall, the settlement set up in London's East End by the Rev. Samuel Barnett to bring young middle class men who had just completed their university education into contact with the local working classes. He set up a small Ruskin class for three pupils, reading texts which were newly available in cheap editions.

His skills as a publicist are illustrated by the involvement of the eminent figure of G. F. Watts (1817–1904) to write the preface. Watts wrote:

> *It is certain that any hope of vital art in England, and indeed, anywhere, in modern times, must be based on working, not dilettanti principles. An art cannot be grafted, or planted, it must spring from its native soil, or it can never flourish in the right nobleness of full health and vigour.*
>
> *From a nation of designers and handicraftsmen, from a people intolerant of ugliness and vulgarity in all the common surroundings of their lives, an age dignified by the highest expression in great art might be hoped for.*
>
> *To the fine designer and worker in metal, in iron, in this iron age — the carver in wood, the moulder in clay, the handicraftsman who can put a living art into the hand and under the eyes of all in the household of rich or poor, we look now for our most vigorous and healthy art-work ...* [5]

The following year, in 1891, Ashbee published *An Endeavour towards the teaching of John Ruskin and William Morris.* [6] The extract below illustrates the development of his ideas for a country-based craft community ten years before the Guild's move to Chipping Campden, Gloucestershire.

2.2.1 From *Transactions of the School and Guild of Handicraft* edited by C. R. Ashbee, Vol.I, 1890, pp 19–22

> *The reading of Ruskin led to an experiment of a more practical nature, and out of Fors Clavigera and The Crown of Wild Olive, sprang a small class for the study of design. The class grew to thirty, some men, some boys; and then it was felt that design needed application, to give the teaching fulfilment. A piece of practical work, which involved painting, modelling, plaster-casting, gilding, and the study of heraldic forms, gave a stimulus to the corporate action of the thirty students, and the outcome of their united work as dilettanti was the desire that permanence might be given to it by making it work for life and bread. From this sprang the idea of the present Guild and School.*
>
> *Very undefined at first, the notion was that a School should be carried on in connection with*

a workshop; that the men in this workshop should be the teachers in the School and that the pupils in the School should be drafted into the workshop as it grew in strength and certainty.

Wisdom pronounced the experiment from a business point of view as entirely quixotic, and precedent for it there was none. The little Guild of three members to begin with, and the larger School of some fifty members, was however started in its present form; the top floor of a warehouse in Commercial Street was taken for two years, to serve as workshop and school-room combined; it was polychromatized by the pupils, and the Guild and School celebrated its inauguration on June 23rd, 1888. A kindly public gave the funds for supporting the School for two trial years; while the Guild, launching as an independent venture, announced its intention of taking up three lines of practical work; wood work, metal work, and decorative painting, and intimated the ambitious hope that it would one day take over the School, for which purpose, when formulating its constitution, it laid by a first charge on its profits.

The little workshop in Commercial Street saw many vicissitudes, and unexpected developments. Strange new things had to be learnt, new conditions and new experiences. The introduction among its members of some of the leading trades-unionist workmen — an indispensable element in the solving of an industrial problem — gave to the Guild that peculiar character which has been the principal reason of its success so far.

The marriage between the stolid uncompromising co-operative force of trades unionism, and the spirit that makes for a high standard of excellence in English Art and Handicraft, has so far proved a fortunate one; and a younger generation is already beginning to tell of a life and tradition of its own.

We look back now with wonder to the circulars issued in the days of the beginnings, and ask how far the original intention has been warped, and changed, and twisted; but the central ideas have always been maintained — that the movement shall be a workman's movement; that it shall be one for the nobility and advance of English Art and Handicraft; that it shall be developed not on the basis of mastership, in the ordinary sense, but co-operatively as an industrial partnership; and that the arts and crafts, united in the Guild, shall be the children of the mother art of architecture. This is the basis upon which all has been built up.

On the first birthday of the Guild and School, celebrated by a supper, a cake, and one candle, the Guildsmen numbered eight, and the School, increased to several classes … counted an average of seventy pupils, men and boys.

2.2.2 From *An Endeavour towards the teaching of John Ruskin and William Morris* by C. R. Ashbee, Essex House Press, London 1891, pp 39–40

Perhaps some day, some English landlord who has watched from his point of view the economic evil that has driven his people into the towns, has seen his farms dying away, & his small tenantry and labourers gradually dispersed, may hold out the hand to us, & make it possible for us to carry out our works in combination with some form of agriculture by small holdings, market gardening, or

co-operative farming. For we indeed realize, from our side, the economic evils of the town. I believe this can be done if tried on a sufficiently comprehensive and yet a sufficiently unpretending scale. The experience of my friend Edward Carpenter and others who have attacked the problem from a simple, direct and human point of view, has gone to show that this is quite possible, if two things are borne in mind. First, if some other occupation besides architecture alone be carried on, and second, if the bulk of the produce reared be retained for the consumption of the dwellers on the land themselves. My study of the character, habits and surroundings of the London workman convinces me too that there is a third factor which, if rightly applied, may help to solve the economic difficulties of a country district:- his potential thriftiness, his actual wastefulness. By this I mean that the workman, as I know him, is by nature capable and willing to be thrifty, but the social and industrial conditions by which he is surrounded, whether in the conventions of his home, or in the traditions of his workshop, tend to dissipate his energies, to make him wasteful, callous, thriftless. To put the case plainly, it would with careful regulation be, I believe, quite possible on the one hand to retain an existing output with a reduction of the working hours, and on the other, to save the time now spent in apparent recuperation or rest:- such rest as is found among the gas-lights of the Mile End Road, in the tram-car, the train, or in stuffy rooms at overstudy of the evening newspaper, — in tilling the soil.

I am of opinion that if our people had gardens of their own to cultivate, and worked fewer hours at their productive work, they would with a little organization produce quite as much of their handicraft as before, and in addition the bulk of the produce needed for their own consumption; while the gain in health to their families and in the amenities of life would be incalculable.

2.2.3 From 'The Guild of Handicraft: A Visit to Essex House', anonymous article, *The Studio*, Vol.XII, 1897, pp 28, 30, 34, 36

By the time that the Guild was three years old a larger habitation was required, and an ideal home was found in Essex House down the Mile End Road, where the Guild removed in 1890, and continues to remain. There was still the teaching side to the movement down to the year 1896, when the pupils numbered over 200. The workshop was self-supporting, paying indeed a creditable interest on the capital invested, and having the school as a first charge on its profits. The school could never, at such fees as might be charged, be independent of outside assistance, which was in general forthcoming. The whole experiment was a distinct success, so much so that it was imitated at Birmingham, Newlyn and many other places. Meanwhile the County Council had proposed interesting itself in Technical Education and founding its Polytechnic Institutes. Instead of subsidising existing institutions, the Council determined to establish others of its own. This being in due course done, the school of handicraft became exposed to the competition of nominal fees, and of course no private adventure can stand against schemes supported out of private money. The school had therefore regretfully to be closed. ... The Guild has a record on its teaching side of which it

may well be proud, not in work done at its own head-quarters, but in the supply of teachers and inspectors to various county councils throughout the country.

[...] note the somewhat simple architectural character of most of the objects. A certain classic simplicity of design and an avoidance of what is known as "trade finish" may be pointed to as most striking characteristics. [...]

A peculiarity of Essex House jewellery is the insistence upon the aesthetic as opposed to the commercial value of precious stones. Colour is a quality always held in view, and thus we find combinations of copper and yellow crystals, gold and topaz, silver and obstein, red enamel and amethyst, blue enamel and opal, and the use of a variety of stones contemptuously regarded by the ordinary jeweller as "off colour" or unmarketable. [...]

While the working side of the Guild is assiduously attended to, under the supervision of Mr Adams, who is general manager, the social side of the community is not forgotten. On the last visit we had occasion to make, there were festivities in progress in the place to celebrate the marriage of one of the members. There is an annual supper as well as various other functions. We have dropped in on a Wednesday evening and joined Mr Ashbee at supper with his apprentices. Some of the guildsmen come in after supper, and sometimes an evening is spent in conversation interpolated with songs, catches, and so forth. Indeed, one cannot but think that it is just this quality of human relationship and the effort of the guildsmen to create a method of life that shall be not merely commercial, which gives to many of the articles turned out at Essex House the individual character to be found in them. [7]

2.2.4 The Guild Book of Rules 1899 in *Craftsmanship in Competitive Industry* edited by C. R. Ashbee, Chipping Campden 1908, pp 226–7

The Guild of Handicraft is a body of men of different trades, crafts and occupations, united together on such a basis as shall better promote both the goodness of the work produced and the standard of life of the producer. To this end it seeks to apply to the collective work of its members whatever is wisest and best in the principles of Co-operation, of Trade Unionism or of the modern revival of Art and Craft, and to apply these in such manner as changing circumstances permit or as shall be most helpful to its individual members.

The Guild was founded in the year 1888 and conducted for ten years as a private industrial partnership, all the members who were duly elected into the Guild being from the time of their election jointly liable with the founder for all they had. But in 1898 in order to limit the liability, the business was re-constructed. With a view to safeguarding the old spirit, the old rights, and the old privileges, the former governing body of the Guild was retained but given a definite status. It objects therefore remain the same as of old, viz, to do good work, and to do it in such a way as shall best conduce to the welfare of the workman. And as there are many means that help to this end besides the mere labour in the workshop, so the Guild also seeks to aid its members in such ways as the following.

To pay no less than the minimum trade union rate of wages when such exists.

To afford to the workmen such facilities for improving his position & powers as shall from time to time seem best, seeing that good work and good conditions are inextricably connected.

To encourage the holding by the Guildsmen themselves of the capital needed for conducting the business to the end they may some day become the sole owners. To promote among old or young the study of good craftsmanship by means of technical classes or otherwise.

To help with a library of such works as may be most helpful to its members, and to promote that other side of life, which whether in time of holiday or work, whether in sports, by music, by drama, or any form of Art brings men together and helps them to live in fellowship.

2.3 Kenton and Company 1890–2: Suppliers of 'furniture of good design and the best workmanship'

Kenton and Company was a short-lived but significant enterprise in the history of Arts and Crafts furniture. The circular reprinted here is undated but was probably produced at the time of its formal registration as a company in February 1891. Gimson wrote to his sister 'You are welcome to the K & Co. circulars. We have two or three hundred that we don't know what to do with, and another distributor may mean another order. I am glad you approve of them. I thought the 'excellence of design' might have been omitted.' [8]

2.3.1 Kenton and Company circular *c.*1891

KENTON AND CO., LIMITED.

THE object of this company is to supply furniture of good design and the best workmanship, and to undertake decorative work generally. All the members of the company will be designers, and will personally superintend the execution of their work by their own workmen. The company will also prepare designs and estimates for furniture and decorative work.

Each piece of furniture will be signed by the designer, and it is hoped that in this way, and by the observance of a high standard of excellence both in design and workmanship, something of the recognition already allowed to works of sculpture and painting may be extended to individual pieces of furniture. It is also hoped that such an association of designers working on common lines and personally controlling their workmen, may succeed in again establishing a school of furniture such as existed in England down to the end of the eighteenth century.

The company consists of the following members:-

SIDNEY H. BARNSLEY. [9]

REGINALD T. BLOMFIELD, M.A. [10]

ERNEST GIMSON. [11]

W. R. LETHABY. [12]

MERVYN MACARTNEY, M.A.

HAROLD MALET. [13]

STEPHEN WEBB. [14]

The Company are now prepared to execute orders at their works [15]
JUBILEE PLACE, KING'S ROAD, CHELSEA. [16]

2.4 Architecture as Craft

Two extracts from *Architecture, a Profession or an Art* edited by R. Norman Shaw
and T. G. Jackson, John Murray, London 1892

This book was written in reaction to the attempt by the Institute of British
Architects to make architecture a closed profession with entry by examination.
Many of the Arts and Crafts architects, such as Lethaby and Gerald Horsley
(1862–1917), believed that it should remain essentially a craft taught by masters
and with close links to the arts and the building crafts.

 Lethaby's essay starts with a quote from Ruskin's *Stones of Venice*, 'It is foolish
and insolent to imagine that the art which we ourselves practise is greater than any
other: but it is wise to take care that in our hands it is as noble as we can make it.'
It includes several other quotes from the same source, most notably the passage
which ends: 'It would be well if all of us were good handicraftsmen in some kind.'

2.4.1 From 'The Builder's Art and the Craftsman' by W. R. Lethaby in *Architecture*, pp 157, 164, 167–8, 169, 170

*In every work of art there is a balance of motive and method, of subject and style: more properly
it is the* method *or the* style *that is art — work rightly done, fitly framed together. The art of
architecture is thus the co-ordination of the several crafts in the achievement of right or beautiful
building; and this not only in the outer form and adornment, but in the very structure and
anatomy. Architecture is the easy and expressive handling of materials in masterly experimental
building — it is the craftsmen's Drama. [. . .]*

 *If you want to learn architecture, you must study architecture — that is, architectural
construction, not the gymnastics which will overleap the building act. You must pry into material.
You must learn the actual 'I know' of the workman. Work manually at a craft — if you begin with*

one you will end with many — not with a view of gaining what is called 'practical experience' but to gain the power of real artistic expression in material. [...]

If you choose the professional part you may still call yourself architect; although the drift of tendency is not set in that direction, there is probably time for you to be successful, to ask a '100-guinea fee' and to reach the end of that vista. If, on the other hand, your choice is entirely for your art, you will certainly be poor, because much work cannot be properly done by one person. Perhaps too your employer may for a time despise you as a handicraftsman. But you will have the craftsman's joy in his craft. You will have a place in life for a whole-hearted ambition, that greatest of all crying wants — a noble ambition, to do good work on the earth before you die: to be a leader, perhaps, in the art of making those things by which man lives; to bring nearer the time when all life will be beauty.

This movement is actually going forward in the crafts. Mr. Morris, when in an architect's office, was one of the first to put to the test the assertion that the art of doing things could only be displayed in doing them — in thinking through the material and the tools — and that 'professional improvement' was necessarily away from art. Others have followed, and many young architects, instead of leaving building design, throwing up the whole thing in disgust, and taking to landscape-painting, are now painting ceilings, painting glass, carving in wood and stone, modelling in plaster, and metal-working. The next step will be for the architect to associate with himself, not thirty draughtsmen in a back office (a number which I understand has been exceeded), but a group of associates and assistants on the building itself and in its decoration. [...]

At present we are trying to paint our picture by means of measurements and written directions, to do our sculpture by detailed drawings, and all by lowest tender; is it any wonder that we fail? But we have only to get to work with the past for our guidance, nature for our inspiration, the brotherhood of the craft for praise, and a true art will as spontaneously spring up as lilies in the spring. [...]

Thus will disappear the difficulty as to the time it is possible to devote to the supervision of any one building, for the architect, making the general scheme and working personally in realising the decorative portions, will be for some considerable time actually present at the works.

By this means also, the building craftsman who displays an aptitude for general design will then be able to become a building director — an architect ... Thus the movement actually going forward is not that of making architecture, a profession which were impossible, but it is that of transforming 'architects' into artists who will enter into the joy of their craft. [...]

The architect can only be permitted to remain the ruler in the kingdom of the crafts if he shows himself capable of lifting building once more to the place of a real imaginative and emotional art.

2.4.2 From 'The Unity of Art' by Gerald Horsley in *Architecture*, pp 195–7

The estrangement amongst the arts and the members of the great art family has been for more than a century a very active agent in lowering the general condition of art ... Until the arts are once more

united and work in combination, we cannot hope for a general revival of art in all its branches.

Instead of seeking reconciliation with the sister arts, architecture has taken refuge in a series of revivals of mere forms of past art, thus producing works which of necessity have less of vitality the nearer they succeed in approaching their models; and there has been but little room for the growth of those slight germs of artistic life that have from time to time shown themselves. We are, in truth, face to face with the fact that while for centuries art was the greatest vehicle of expression possessed by the people, it has now ceased to be so; and it is not an answer to this statement to say that other thoughts and aspirations, not of art, are predominant in the lives of men. [...]

But if art is ever to become once more a genuine and spontaneous expression, there must be a complete accord and unity between all artists and handicrafts. [...]

It is not enough for artists alone to understand this. Those who are laymen in the matter of art must also learn to realise the present position of affairs, and the urgent necessity of a better method. If the sympathy of artist with artist has grown cold, that between artist and people is absolutely frozen. The easy tolerance with which most persons endure gross ugliness, meaningless ornament, and absence of thought in their public and private buildings, and the rampant unintelligence that rules in house design and decoration, show the total want of sympathy of art with men or men with art.

2.5 Plain Handicrafts: Practical Advice for Craftsmen and Women

Three extracts from *Plain Handicrafts* edited by A. H. Mackmurdo, Percival and Company, London 1892

The purpose of this collection of essays was to provide direction for the increasing numbers of men and women who were getting involved in craftwork. According to the preface it was a reaction to:

the designs and directions you find in some of the papers which profess to teach you how work may be done are most misleading. They tell you how to make (very badly, if you follow their directions) things that nobody needs, and they lead careless people to believe they can carve, paint, and embroider with little effort of their own and without respect for the beautiful designs of the past.

2.5.1 From 'Of Design and the Study of Nature' by Selwyn Image in *Plain Handicrafts*, pp 5–6

The first, the great thing, is to look for the essential characteristics of any object before us, to understand the make of it, its anatomy and constant qualities ... Suppose we are going to design a pattern for embroidery, and that this pattern is to be founded on a wild rose, and that we have

got a spray of wild rose in front of us for the purpose of studying it. To begin with, we deliberately will pay no attention to whatever in this spray is accidental, to any merely individual details of form or colour. We look at the typical number and shape of the petals, the typical shape and growth of the leaves, the way these join on to the stem, the growth of the stem itself, the placing of the thorns on it. When we know these things thoroughly, we know the idea, so to say, upon which all species of the wild rose are founded ... Till we know these things thoroughly, we are not in a position to make a wild-rose design; we have not sufficient material to work upon, not sufficient material for our imaginative cunning to play with, and shape into a decorative pattern over the space given to us to fill. For design implies two things: it implies, first of all, that we are acquainted with the essential characteristics of the natural object upon which we found our design; and, secondly, that we have imaginative cunning enough to employ these essential characteristics in an arrangement of masses and lines, which fills the space satisfactorily.

2.5.2 From 'Cabinet Making' by W. R. Lethaby in *Plain Handicrafts*, pp 7, 8–9, 10–11, 16

Many of you, I hope, who read this are, or will be, carpenters and joiners, shipwrights, wheel-wrights, waggon-builders — in fact, of those who deal with the cutting and framing of wood. It is a fine thing to be a workman in one of the good old crafts where the hand and eye, individual judgment and experience, have not given way to wholesale production by machine. To make a thing beautifully, and fitted for real service, is a noble act, and needs wide effort. [...]

I should like to suppose you to be living in the country; a country cottage. There, wherever it may be, years and years ago — before the time of the big factories where people tend machines all day, and get so used to the companionship, that they seem not to think of making a strong table or bench for themselves — the furniture was made in the village for the people of the village; made slowly and of strong oak. And because it was to be of so much use and to last so long, it was of worth to make it beautiful too, so there was not a cottage but it had some beautiful furniture. Much of this still remains, and the best education is to go and look at what you can find. Look at such examples until you know them by heart, and know exactly how they were made. When you know what fine things these are, instinctively you will feel that cheap unworkmanlike pretences at ornamentation, are beneath the dignity of a cottage ... These things then you require:

1. Distinctly and firmly to grasp what is the purpose of the thing you are going to make.
2. To set about making it on the lines of work that has stood the test of time, that following the experience of others you may secure thorough construction.
3. To select sound materials, and those most fitted for the work they have to do.
4. To fashion the things in hand in such a way that the result is beautiful — beautiful even when most plain. [...]

It would be quite vain to try to teach the practice of a craft in print; that can only be done by actual contact with a workman who holds it as a tradition received from some other, and so back

and back. *The tools, too, are shaped by the experience of thousands of years; saws, planes, chisels, hammers, centre-bits, and gimlets, squares, bevels and gauges, and all the rest of the nice things you must learn to use well; to plane level, to shoot a joint straight and glue it together; to tongue clamps across the grain at the ends, to rebate, mitre, and frame rails into uprights with closely fitted mortise and tenon, to frame up panelling and fit dovetail angles — all this forms but the alphabet.*

If, being able to do good work, you are going to make your room pleasant to live in, whitewash the walls and ceiling; put a little ochre in the wash, but do not on any account use blue for the walls, it is extremely disagreeable. Paint the woodwork a light "buff" or stone colour; some parts, like the skirting, may be black if you like, or the whole can be green, nearly any tint of which will do if you do not call it "Peacock", and think that it is "artistic".

The furniture for such a room will be of oak rubbed up with wax or untouched, or of deal painted. The table top of elm or deal is to be left clean and scrubbed; the chairs may be of ash. Birch, beech, sycamore, yew, pear, cheery [sic], and chestnut, are useful woods. Always get good material, and put sound work into sound wood.

Now comes the point at which we must consider design. Do not pretend to cleverness nor originality — what is the good? Consider place, use, size, strains, and other conditions of make, shape, and service. . . . if you do copy, let it be with a difference for invention's sake. [. . .]

[Lethaby then gives suggestions for furniture: a shelf, a box for clothes, a bench to go along the wall under the window, stools, a cradle, a table, a settle and a cupboard or a dresser.]

Should you make all these, with a bookcase which you must yourself design — I think you might buy a nice clock, — then with some flowers in the window, a cat, and good plain things to eat, I am sure you ought to be happy.

2.5.3 From 'Embroidery' by May Morris, in *Plain Handicrafts*, pp 46–7

The elements which insure the success of a piece of needlework are: (1) good design, (2) skill in selecting and arranging colours, (3) skill and invention in the stitches employed, and (4) choice of materials and suitability of the work done to a certain definite purpose, so that it shall not be meaningless, but rather a thing of use and of individual interest. [. . .]

As regards colouring, the first necessity is to get all tones as brilliant and full as possible, entirely disregarding the advice of the dilettante who bids you use dull greens and faded blues as "soft quiet colours." To handle bright colours skillfully is part of the embroiderer's art, and can only be achieved after a certain amount of experiment and failure, in other words, by experience. The general effect of a fine piece of colouring is neither startling nor garish, but rather subdued than otherwise, and yet on looking into it, the colours used are found to be of the brightest and clearest shades possible; light turquoise-blue may be found outlined with orange, crimson laid against green, and orange next to that, every imaginable combination of colours which, in themselves brilliant, are so balanced and so played off against each other that they form a harmonious mosaic of colour, as it were, peaceful and quiet with all its richness.

2.6 Art and Dress: The Healthy and Artistic Dress Union and its Journal *Aglaia*

Two extracts from *Aglaia*, No.3, autumn 1894

William Morris expressed the importance of dress and its relationship to art in 'The Lesser Arts of Life' in 1882. He wrote despairingly that '… civilisation has settled for us males that art shall have no place in our clothes'. He promoted the necessity of 'rational and beautiful costume' for women, begging '… do not allow yourselves to be upholstered like armchairs, but drape yourselves like women.' [17] Dress and fashion was also discussed by other Arts and Crafts writers including Lewis F. Day and C. F. A. Voysey.

The Healthy and Artistic Dress Union, founded on 2 July 1890, was one of a number of societies set up to promote these ideas. There was no president but a number of influential vice-presidents including the painter G. F. Watts and his wife, Mary Seton Watts; Lady Wentworth, a founder-member of the Home Arts and Industries Association, and Sir Spencer Wells M.D. The Union emphasised the importance of education and vigorously discouraged personal singularity of dress. Its membership included many members of the Art Workers' Guild including Walter Crane. The holistic Arts and Crafts approach towards dress was expressed by one contributor, Henry Holiday (1829–1927), in a paper, 'The Artistic Aspect of Dress', read to a meeting on 6 May 1892 thus: 'In making a plea, then, for greater beauty in our dress, I am pleading really for a greater spiritual beauty in our lives.' [18]

The aims of the Union were set out in an introductory statement in the journal. It was not intended as a fashion magazine because the development of healthy and artistic dress must be a gradual process. For the movement to be successful there must be a 'genuine growth of healthy taste' in contrast to the narrow and short-lived development of aesthetic dress. The Union did not want to add to increase of changes of fashion but to encourage every favourable trend and discourage 'all that are unwholesome or tasteless'. It did not want individual members to be 'chargeable with personal eccentricity' but saw the positive educational effect of respected members of the public wearing a perfect form of dress. Finally it wanted to work in conjunction with established manufacturers.

2.6.1 From 'On the Progress of Taste in Dress in Relation to Art Education' by Walter Crane, *Aglaia*, No.3, p.13

Crane found picturesqueness in the traditional clothing worn by labourers and country people and to some extent in the clothing evolved for sports such as

'cricketing and boating flannels, parti-coloured jerseys of our football teams, cyclists' riding dress'. He wrote: 'If we lived simple, useful, and beautiful lives, we could not help being picturesque in the highest sense. *There* is the modern difficulty. We are driven back from every point to the ever present social question.'

> *Modern society encourages the ideal of do-nothingness, so that it becomes an object to get rid of the outward signs of your particular occupation as soon as you cease work, if you are a worker, and to look as if you never did any if you are not. This notion, combined, perhaps, with the gradual degradation of all manual labour under the modern system, has combined, with business habits and English love of neatness, and, perhaps, prosaic and puritan plainness, to produce the conventional costume of the modern "gentleman" — really the business man or bourgeois citizen.*
>
> *The ruling type always prevails and stamps its image and subscription upon life everywhere.*
>
> *Thus the outward and visible signs of the prosperous and respectable, the powerful and important, have come to be the frock coat and tall hat — gradually evolved from the broad brim and square cut jerkin of the Puritan of the seventeenth century. [...] What modern costume really lacks is not so much character and picturesqueness as beauty and romance — a general indictment which might be brought against modern life. We are ruled by the dead weight of the prosaic, the prudent, the timid, the respectable, over and above the specialising adaptive necessities of utility before mentioned. [...]*
>
> *I think there is no doubt that we do see the signs of artistic culture, over and above natural distinction of choice, more frequently in the dress of refined and cultured women in our days than at any former period, perhaps, since the first half of the sixteenth century. There is more variety, more individuality; signs of that increasing independence of thought and action which distinguish our countrywomen.*

2.6.2 From 'On the Progress of Taste in Dress in Relation to Manufacture'
by A. Lasenby Liberty, *Aglaia*, No.3, pp 29–30

Arthur Lasenby Liberty, founder of the oriental bazaar and department store in Regent Street in London's West End, was one of the manufacturers that the Healthy and Artistic Dress Union wanted to work with. In this piece for the final issue of *Aglaia* in the autumn of 1894 he wrote about the development of fabrics specifically for artistic clothing. He described how (to begin with) Western methods of dyeing and printing were applied experimentally to Eastern woven fabrics, especially silks, to secure certainty and rapidity in the reproduction of approved colours and designs. Eastern examples were then copied and popularised under Hindu names. Then manufacturers in Europe adopted Eastern methods to produce new materials such as the 'thetis' brocade developed especially for artistic mourning dress.

The supply of more beautiful materials appears to be due entirely to some few who have more or less efficiently combined the roles of retail distributor with those of artist and producer, who, because the manufacturer appeared helpless or indifferent, reversed the usually accepted idea of procedure, struck out into original paths, and in the position of "the middleman" dictated to manufacturer and designer alike. [...]

The soft cashmeres of India were for a time the only woollen materials obtainable at all complying with the requirements of the awakened artistic demand. After many experiments, failures and disappointments it was proved possible to reproduce on Western looms woollen materials combining almost the identical characteristics of the Indian cashmeres ... with the very great advantage that the Western loom-made materials were more durable and less expensive. The first in order of issue of the new woollen materials was, for reasons before alluded to, introduced under cover of the suggestively Indian name of Umritzur cashmere, and all subsequent Western-made soft-finished cashmeres are developments or variations of the so-called Umritzur cloth. The many beautiful colourings subsequently introduced in these woollen materials are without exception reproductions of Eastern prototypes.

2.7 The Architect's Role in Interior Design

2.7.1 From 'An Ideal Suburban House' by M. H. Baillie Scott, *The Studio*, Vol.V, 1894, pp 127, 130–1

This was the first of many articles written by the architect M. H. Baillie Scott for *The Studio*, providing him with a showcase for his ideas and his designs. Both he and Voysey took a holistic approach to the architect's role encompassing interior as well as exterior design (Fig.5).

Every one who has experienced the discomforts of the average suburban house will admit that there is ample room for improvement in its arrangement; and it is with a view to show how a few of its most glaring defects at least may be corrected that the present writer has designed the house which is here illustrated. [...]

In the treatment of the bedrooms ... it is suggested that as much variety as possible should be introduced. One bedroom may be finished in white enamel, with perhaps a blue wall-paper; another may be treated in golden yellows or flame tints; while a third may suggest the homely character of the hall. In any case, it must be borne in mind that a definite final effect should be aimed at, and the room should not present the usual accumulation of articles, which, however pretty in themselves, bear no actual relation to a definitely conceived scheme. In selecting the furniture, it is easier to point out what to avoid than what to choose. On the one hand, we have the handsome mahogany suite; on the other, the "Art" suite in painted deal, neither possessing the quality of simple dignity which is regarded as essential. The use of "fitments" will often result in a very good effect, but they

should be used with due consideration of their limitations in rooms which are sufficiently broken up by their outline to suggest this method of furnishing.

It is difficult for the architect to draw a fixed line between the architecture of the house and the furniture. The conception of an interior must necessarily include the furniture which is to be used in it, and this naturally leads to the conclusion that the architect should design the chairs and tables as well as the house itself.

2.8 Art, Beauty and Utility in Everyday Life

Three extracts from *Art and Life, and the Building and Decoration of Cities*, lecture series, London 1897, published by Rivington, Percival and Co.

The Arts and Crafts Exhibition Society held its fifth exhibition at the New Gallery in the autumn of 1896. The accompanying lecture series was published as *Art and Life, and the Building and Decoration of Cities* in 1897. According to the preface, the lectures were 'printed precisely as they were delivered'. The first lecture by T. J. Cobden-Sanderson began with some words about William Morris, late president of the Arts and Crafts Exhibition Society, who died on 3 October 1896, the opening day of the exhibition. 'Work, incessant work, with Beauty for our everlasting aim – *this* is the William Morris … which we all … ought to cherish and abide by for ever.'

He went on to describe the aims of this lecture series as, '… the extension of the conception of art, and, more especially, the application of the idea of beauty as well as of utility to the organisation and decoration of our greater cities'. [19] As well as the extracts below, the series included contributions from Walter Crane on the decoration of public buildings and Halsey Ricardo (1854–1928) on the use of colour in architecture.

2.8.1 From 'Of Art and Life' by T. J. Cobden-Sanderson, in *Art and Life* pp 7, 32–3

Art, as a manifestation of the artistic spirit, has its origin, or, to speak more correctly perhaps, its opportunity in Craft, and Craft in the needs of life. And as the needs of life vary from generation to generation, and from age to age, so must vary the objects of Craft, and with them the modes of manifestation of the artistic spirit.

I have defined the function of Art: it is the setting in order of the house of mankind. I now define the future of art: it is the setting in order of the house of mankind in exalted consciousness of the environment amid which it is placed. [...]

But meanwhile what may be the immediate function of Art? And in the meanwhile what its immediate future?

It is, as far as may be, to do each thing, however small, however great, it is to do each right thing well, in the spirit of an artist, in the spirit of the whole. Art is not decoration, it is not painting, it is not sculpture, it is not architecture, it is not verse, it is not music. It is, indeed, all these things in turn. But it is primarily, and chiefly, and always, the doing a right thing well in the spirit of an artist who loves the just, the seemly, the beautiful; and its immediate future is to apply this idea of itself to the whole of life and not to the objects of the so-called finer and minor Arts only.

Life, then is stupendous energy, and at not one moment of time is that energy suspended. First, the energy of the universe without man, then of man in unison with the universe, and of the two conjointly. That stupendous energy in its main and in its minor strains, in entirety and in detail, is the province of Art, and by Art must be controlled and directed. To what end? To what immediate end?

To the creation of the City Beautiful, the beautiful house of Mankind, and therein, and in keeping with the spirit of the Whole, the creation of the Fit, the Seemly, and again the Beautiful.

2.8.2 From 'Of Beautiful Cities' by W. R. Lethaby, in *Art and Life* pp 102–4

We should approach the question of beautifying London from the side of tidying up of necessary work: there is little hope right now of Art produced with malice aforethought. We must, above all, get rid of the grandeur idea of Art. We have only to go to Vienna to see what modern mechanical grandeur will do for a city. Art is but the garment of life. It is the well doing of what needs doing. Art is not the pride of the eye and the purse, it is a link with the child-spirit and the child-ages of the world. The Greek drama grew up out of the village dance; the Greek theatre was developed from the stone-paved circles where the dances took place. If we gathered the children who now dance at street corners into some better dancing-grounds, might we not hope for a new music, a new drama and a new architecture?

Unless there is a ground of beauty, vain it is to expect the fruit of beauty. Failing the spirit of Art, it is futile to attempt to leaven this huge mass of "man styles" by erecting specimens of architect's architecture and dumping down statues of people in cocked hats.

We should begin on the humblest plane by sweeping streets better, washing and whitewashing the houses, and taking care that such railings and lamp-posts as are required are good lamp-posts and railings, the work of the best artists attainable.

2.8.3 From 'Of Public Spaces, Parks and Gardens' by Reginald Blomfield, in *Art and Life* pp 208–9

For in all these matters, the most advanced thought is that which puts itself back. We have made tremendous strides in science and mechanics, but meanwhile the arts have been neglected and starved

of their right intellectual food. As we have advanced in one direction, we have in this century fallen back in others. We have lost our sense of proportion, we have less understanding of the grace of life than our forefathers, less knowledge of how to make our surroundings comely and reasonable; and we shall not find the way to this by desperate attempts at making our art and our language modern. In so doing we only make it vulgar. We must search again for tradition. We have to recover that fine selection, that subtle rise of proportion, which are the first elements of style, the power of rejecting the irrelevant and unessential, that nice adaption of means to ends which tends to become more and more the greatest quality of art.

We have indeed to arrive at a new understanding of what art is, and what it can do for us in our life.

2.9 A Designer in the Cotswolds: Letters from Ernest Gimson

Gimson and the two brothers, Ernest and Sidney Barnsley, moved to the Cotswolds in April 1893 to live the Arts and Crafts ideal as architects and craftsmen. They found a dilapidated farmhouse, Pinbury Park, to rent. Ernest Barnsley was responsible for restoring the house and lived there with his wife and two daughters. Gimson and Sidney Barnsley stayed in rented accommodation in the hamlet of Ewen near Cirencester until they had converted outbuildings on the estate into accommodation for themselves. [20]

2.9.1 To Margaret Gimson, [21] 12 April 1894

Dear Maggie,

I am alone with the pups and cat as Sid B is in London for two or three days, and when you are alone the time usually given to conversation may be profitably given over to letter writing …

I was going to send you some flowers – snakes heads or toads heads – or Guinea hen flowers – in plain English Frittillaria Meleagris. Mrs Barnsley and Lucy [22] *were to have driven over from Pinbury and to have gathered them on their way for distribution among our friends and our loves and best wishes, but they didn't come … you must take the will for the deed and thank me for the flowers. Aren't they beautiful!*

You ask how our cooking is getting on. We have got as far as Welsh Rabbit and fried onions. We light the fire at about 7.30 in the evening and cook ourselves little suppers. And not only that, we eat them, and wash up as well. I have often wondered why so many men felt such a strong desire for a smoke after a meal. It is because they don't wash up. With me it now takes the place of the cigarette.

Your affectionate brother
Ernest

2.9.2 Three letters to Sydney Gimson, [23] 1898. The first is dated 9 March, the
subsequent ones are undated (Fig.6).

Dear Syd,

I have done what I can with the bookplates and send you the results. They are neither of them satisfactory. I will try again if you like in two or three months. At present I am on with other things. The simpler one is the better of the two. That would be just passable if it were printed on good paper. But it is not good. I should not like to sign my name to it. I don't understand designing for reduction. And it would require a more microscopic eye than mine to draw it real size.

Let me know if I shall try again or find somebody else to do it for you.

I hope you are all well. Give my love to the wife and children, yr affectionate brother, Ernest.

Dear Syd,

I am sorry you like the book plate. However I will see what I can do with it if you will please return the proofs to me with the drawing. I must get it done for you as it wants a little touching up in places particularly if you think it should be reduced to 2 inches sq. I will be good and get it done at once. The paper I agree should be thin but it should be a little rough too and certainly gummed at the back. All the proof papers I sent you were particularly bad.

Yrs EWG

Dear Syd,

May I have the other book plate and some white proofs as well as the one you have sent me? I believe I could make it the better of the two now. I will do what I can to bring out the name more clearly and to make the background a little less confused. I will send them both back to you when I have made the alteration so that you may choose again. I am sorry to propose the extra delay.

Yrs EWG

2.9.3 To Margaret Gimson, 17 September 1899

My dear Maggie

I will expect you then a week tomorrow and will walk in to meet the 3.35 train to have tea with you in Cirencester and to help carry your bag. If you bring more than I can carry you can make a little parcel of things you want for the night and the rest can come by carrier.

I am glad you are going to take me for some tramps after you have rested for a day or two. The Schultzerian [24] man is coming too. So when you have exhausted me you can take the out of him. If you want to go with him first you must bring your bicycle so that I shall not be able to

accompany. You will probably just see the Walkerian [25] *one and maybe Mrs Cocquerelle* [26] *and later in your visit Fra Fillipo.* [27] *Mrs Walker and Dolly* [28] *(I have orders to call her Dolly) will still be at the cottage. But a woman of your nerve is not to be frightened.*

I have sent your embroidery to the A. & C. [29] *It has met with much favour here. And being in a showing off humour I have sent five other things with it. I tell Walker that if they are rejected he will have to bring them back with him so I specs he will see that they are shown.*

By the time you come I shall have finished the Orkney [30] *bit of work and the first part of the Surrey cottage and shall have plenty of time to "rag" you.*

With love to mother and all of you.

from yr affectionate brother,

Ernest

2.10 Arts and Crafts Aesthetics and the Commercial World: Furniture

2.10.1 From 'A Note on Simplicity of Design in Furniture with Special Reference to some Recently Produced by Messrs Heal and Son' by W. Gleeson White, published privately 1899, pp 32–3

Ambrose Heal (1872–1959) was the great-grandson of the founder of the firm which began as a mattress and feather bed manufacturer in Tottenham Court Road, the heart of London's furniture trade. He joined the family firm in 1893 and promoted the simple cottage style of furniture inspired by Arts and Crafts aesthetics. Initially it was not well received by his colleagues, who described his designs as 'prison furniture'. [31] He quickly established a market for his work, aided by his instinctive grasp of marketing and promotion, of which this essay is an example, made more effective by the distinctive woodcuts of both individual pieces and room settings by C. H. B. Quennell (1872–1935).

W. Gleeson White was editor of *The Studio* when he agreed to write this essay for Heal and Son. He defended charges of involvement with a commercial venture in the essay, writing:

If in approving Mr. Ambrose Heal's admirable designs for bedroom furniture it also reflects praise on his firm, the charge of puffing commercial wares thereby may be risked lightly. To speak up for good things, whether made by an obscure amateur, or by manufacturers in a large way of business, is the duty of those who are engaged in recording the progress of the applied arts.

Heal's work was first shown at the sixth Arts and Crafts Exhibition in 1899 and at the Paris exhibition of 1900 he produced a room set designed by his cousin, the architect Cecil Brewer, which included bed hangings designed by Godfrey Blount.

Simplicity has been said to be the final refuge of the complex. Nor is the statement really a paradox. To be simple in decoration is always to be in good taste, and, as a rule, to fulfil the intended purpose more satisfactorily. Where simplicity is gained without needless austerity there can be little doubt but that it possesses a far more abiding charm than ornate decoration is likely to have, although equally well carried out. For years the bedroom has been accepted as the one room in the house where simplicity was most important. Even the most debased collector of superfluous bric-a-brac, occasional tables, and other drawing-room pitfalls, is willing to leave the bedroom comparatively bare. This practice has been reinforced by the opinions of sanitarians and sentimentalists alike. But scant furniture and mere utility does not represent altogether what we understand by true simplicity, which should include something of far higher quality; and prove elastic enough to allow of comfort and comeliness, as well as the cleanliness which it usually proclaims as its chief, and is often its sole, virtue.

The furniture with which this note is concerned may be safely regarded as typical of the simplicity which provides comfort and comeliness as well as cleanliness. More than this, it satisfies those who are interested in good design and honest construction. Without reverting to the quasi-Gothic style, all popular when Pugin and the mediaeval revivalists were the leaders in taste, it accepts the true principles of that style, which many of the followers of those ardent crusaders against shams burlesqued in their anxiety to show the tenon of every mortise and the head of every nail.

In short, the beauty which many of the pieces undoubtedly possess is due to well-chosen material, admirable proportion, harmonious design and rigid economy of ornament. Without any wish to draw comparisons, it may be doubted if furniture so admirably fitted for its purpose and so good in design has ever been kept for sale in the ordinary way of business … Here are stock patterns in furniture adapted for people of moderate means, as well as for those who can afford to pay more. While some few items may perhaps be open to criticism, of the whole it is possible to speak with exceptionally warm approval. Had such things been exhibited either by professionals or amateurs at any of the exhibitions of the applied arts in London or the provinces, critics would have extolled them, and rated the trade on its indifference to the demands of the educated public by its omission to provide such goods. Because they chance to be designed by a member of a firm of old-established manufacturers it would be grossly unjust to regard them as mere "Tottenham Court Road" furniture. The phrase has grown to be a by-word; and it must be admitted that within the long thoroughfare there is still no little to justify it as suspect. But there is also much to remove the stigma. Unless a person is prejudiced and will not be convinced, he must own that in a few windows in this locality, where furniture makers have gathered together, are well-made, well-planned pieces of furniture that would not discredit an architect of established reputation.

Notes

1 Sedding, J. D. 'The Handicrafts in Old Days' from *Art and Handicraft*, Kegan Paul, London 1892, p.67.
2 Ibid pp 51–2.

3　Ibid p.79.

4　Ibid pp 61–2.

5　Watts, G. F. in Ashbee, C. R. (ed.) *Transactions of the Guild and School of Handicraft* Vol.1, 1890, pp 9–10.

6　Ashbee, C. R. *An Endeavour towards the teaching of John Ruskin and William Morris*, London 1891, p.37.

7　This article was illustrated with drawings of the Guildsmen at work by Ashbee's friend, George Thomson.

8　Letter to Sarah Gimson dated 23 February 1891, CAGM.

9　Sidney Barnsley trained in Norman Shaw's office. When the formation of the firm was first being discussed he was on a scholarship studying Byzantine architecture in Greece with Robert Weir Schultz.

10　The architect Reginald Blomfield (1856–1942) probably became involved in the firm because of the difficulties he and Mervyn Macartney (1853–1932) had faced when trying to persuade the furniture trade to take part in the 1890 Arts and Crafts Exhibition.

11　Ernest Gimson trained in Sedding's office. In 1890 he began making turned ladderback chairs, learning the basics of the craft and making himself a pole lathe in the workshop of Philip Clissett, a traditional chair maker in Bosbury, Herefordshire.

12　W. R. Lethaby worked as Norman Shaw's Chief Clerk for ten years. His simple oak designs for Kenton and Co. were a radical and influential departure from his earlier work for Shaw.

13　Colonel Harold Malet was a sleeping partner in the firm.

14　Stephen Webb's name appears here as a member although there are no known examples of his designs made by Kenton and Company. Webb was on the original committee of the Arts and Crafts Exhibition Society in 1888 and wrote the preface on Furniture for the first catalogue that year.

15　The premises in Chelsea were short-lived: the firm established itself in Brownlow Mews near Guildford Street, Bloomsbury. Two exhibitions were held in July and December 1891 at Barnards Inn but the company was wound up over the summer of 1892 due to lack of capital and the architectural aspirations of the participants.

16　A copy of this circular is in the Arts and Crafts archives at CAGM.

17　Morris, W. 'The Lesser Arts of Life' in *Collected Works* edited by May Morris Vol.XXII, pp 262 and 265.

18　The paper was published the following year in the first issue of the journal, *Aglaia*, produced by the Union between 1893–4, p.29. Aglaia was one of the three Graces in classical mythology representing adornment. The cover, designed by Henry Holiday, inspired a sonnet by the Rev. H. D. Rawnsley published in the first issue. Other articles in first issue included 'Medical Side of the Attack on Corset Wearing' and 'Choice from the Fashions'.

19　*Art and Life, and the Building and Decoration of Cities*, Rivington, Percival and Co., London 1897, p.5.

20　These letters are part of a collection in the Arts and Crafts archives, CAGM.

21　Margaret Gimson was Gimson's youngest sister.

22　Mrs Barnsley refers to Ernest Barnsley's wife Alice; Lucy Morley was Gimson's cousin from Lincolnshire who joined the group in the Cotswolds. Her practical experience of living on a farm was invaluable.

23　Sydney Gimson, Gimson's elder brother, who commissioned him to design a bookplate

24　The architect, Robert Weir Schultz.

25　Emery Walker.

26　Mrs Sydney Cockerell.

27　Philip Webb.

28　Dorothy Walker, Emery Walker's daughter. The family rented a cottage at Pinbury from July to September 1899. Dorothy Walker's diaries include the following: 'Went for a ride with Miss Thompson, but Mr Powell and Mr Gimson would walk to see a church at Avening for the Anti-Scrape Society' (28 July). 'Mother and I taken by Mr Powell and Mr Gimson to tea under a monster beech and there was quite a big picnic, after which we played games and had jolly songs' (29 July). 'Gobbled lunch and off to Birdlip. Really a most splendid view but it was too misty to see Gloucester Cathedral and Tewkesbury Abbey … Home, and played with the children in Mr Gimson's workshop with Mr G's clay. Great fun! (21 August). 'Went to draw Mr Gimson's cottage. He asked me in to tea and showed me some of the drawings he did when he was 21, and was so encouraging and kind to me' (8 August).

29　Margaret Gimson was one of several female relatives who worked Gimson's embroidery designs.

30　Gimson was making chairs for Melsetter, the house on Hoy in Orkney designed by W. R. Lethaby.

31　Quoted in *A History of Heals* by Susanna Goodden, Heal & Son Ltd, London 1984, p.16.

CHAPTER THREE
ARTS AND CRAFTS PRACTICE
AND EDUCATION 1900–09

Introduction

By the end of the nineteenth century, the Arts and Crafts Movement had succeeded in establishing British design at the forefront of developments in the western world. Magazines such as *Dekorative Kunst* in Germany and *The Craftsman* in the United States regularly featured the work of British designers. The Arts and Crafts Exhibition Society promoted exhibitions of members' work abroad, particularly in France and Belgium, while C. R. Ashbee's furniture featured in the eighth Secession Exhibition in Vienna in 1900. Continental developments caused a certain amount of disquiet and Ashbee, Lewis F. Day, Walter Crane and C. F. A. Voysey all published criticisms of Art Nouveau.

The husband and wife team Nelson (1859–1942) and Edith (1862–1920) Dawson founded the Artificers Guild with Edward Spencer in 1901 and specialized in jewellery, metalwork and enamelling. Numerous Arts and Crafts designers produced work for the Guild during its long history including Henry Wilson, May Morris and Phoebe Traquair (1852–1936). It survived in several reincarnations until 1942.

The Cotswolds became a major centre for the Arts and Crafts. In 1900 Ernest Gimson and Ernest Barnsley went into partnership together and set up workshops at Daneway House, near Sapperton (Fig.7). Although the partnership was short-lived, the workshops expanded and flourished under Gimson's direction. In 1903 their friend, the architect Alfred Powell (1865–1960), started working as an outside decorator of pottery for the Staffordshire firm of Josiah Wedgwood and Sons with Louise Lessore (1882–1956), an embroiderer and calligrapher whom he married in 1906. Their underglaze brush-painted pieces illustrate the freshness and spontaneity of the best Arts and Crafts design.

The most significant development during this decade was the decision taken at the end of 1901 to move the Guild of Handicraft as an entity from the East End to the attractive setting of the Gloucestershire town of Chipping Campden (Fig.8). The move brought new blood to the Guild and a revitalised, although short-lived, sense of purpose. The Guild of Handicraft was forced to close as a limited company in 1908.

3.1 'Text-books of workshop practice': Handbooks on the Artistic Crafts edited by W. R. Lethaby

W. R. Lethaby edited this series,

> to provide trustworthy text-books of workshop practice, from the point of view of experts who have critically examined the methods current in the shops, and putting aside vain survivals, are prepared to say what is good workmanship, and to set up a standard of quality in the crafts which are more especially associated with design [and] to treat design itself as an essential part of good workmanship. [1]

Additionally the handbooks aimed to encourage people to earn a living from artistic craftsmanship. The contributors were practitioners in their chosen crafts and also taught at the LCC Central School of Arts and Crafts where Lethaby was joint Principal. Many of the handbooks were illustrated and a companion volume of large format images was also published (Figs 9 and 10).

3.1.1 From *Silverwork and Jewellery* by Henry Wilson, John Hogg, London, 1903, pp 126–7

Henry Wilson (1864–1934) trained as an architect and took over John Sedding's practice after his death in 1891.

> If you wish to make a pendant for this necklace, it must not merely be an elaborate panel, but should have some central point of interest. You may either read "The Romaunt of the Rose" and take thence whatever suggestion most appeals to you, or you may prefer to put a nightingale singing in the middle of the bower of leaves ... To Make the Nightingale. – First go and watch one singing. There are happily numberless woods and copses near London in which the nightingale may be heard and seen at almost any time of day. Take an opera-glass and find the spot most frequented by the birds and least frequented by humans; sit motionless and watch them while they sing. If you have not seen one before, you will never forget the first sight of the little brown-backed, grey-breasted bird against the sky and leaves, with head thrown back and his throat throbbing in an ecstasy of song.

3.1.2 From: *Writing and Illuminating, and Lettering* by Edward Johnston, John Hogg, London 1906, pp xvi–xviii

> *Developing, or rather re-developing, an art involves* the tracing in one's own experience of a process resembling its past development. *And it is by such a course that we, who wish*

to revive *Writing & Illuminating, may* renew *them, evolving new methods and traditions for ourselves, till at length we attain a modern and beautiful technique. And if we would be more than amateurs, we must study and practise* the making of beautiful THINGS *and thereby gain experience of Tools, Materials, and Methods. For it is certain that we must teach ourselves to make beautiful things, and must have some notion of the aim and bent of our work,* of what we seek and what we do.

Early illuminated MSS. and printed books with woodcuts (or good facsimiles) may be studied with advantage by the would-be Illuminator, and he should if possible learn to draw from hedgerows and from country gardens. In his practice he should begin as a scribe making MS. books and then decorating them with simple pen & colour work. We may pass most naturally from writing to the decoration of writing, by the making and placing of initial letters. *For in seeking first a fine* effectiveness *we may put readableness before "looks" and, generally, make a text to read smoothly, broken only by its natural division into paragraphs, chapters, and the like. [...]*

The essential qualities of Lettering are legibility, beauty, and character, *and these are to be found in numberless inscriptions and writings of the last two thousand years. But since the traditions of the early scribes and printers and carvers have decayed, we have become so used to inferior forms and arrangements that we hardly realize how poor the bulk of modern lettering really is.... A conscientious endeavour to make our lettering readable, and models and methods chosen to that end, will keep our work straight: and after all the problem before us is fairly simple* – To make good letters and to arrange them well. *To make good letters is not necessarily to "design" them – they have been designed long ago – but it is to take the best letters we can find, and to acquire them* and make them our own. *To arrange letters well requires no great art, but it requires a practical knowledge of letter-forms and of the rational methods of grouping these forms to suit every circumstance.*

3.2 Women in the Crafts

3.2.1 From 'Wood Carving' by Maria E. Reeks in *Some Arts and Crafts* edited by
Ethel M. M. McKenna, The Woman's Library Vol.IV, London 1903,
pp 145–58

This book began with a historical account of the development of design in furniture and decoration from the sixteenth to the nineteenth centuries as a background to five essays by women involved in the Arts and Crafts. The editor, Ethel M. M. McKenna (fl. 1890–1905), was a member of the Guild of Women Bookbinders and contributed an essay on bookbinding. The book also included pieces on enamelling, spinning and weaving and photographic portraiture as a profession as well as wood carving. Maria E. Reeks (fl. 1884–1915) began working as an evening class assistant

at the School of Art Woodworking in South Kensington and continued to teach at the school until 1915.

There is no doubt ... that a woman, when she has mastered her craft, does encounter great difficulties in making a practical start unless ... she has an opening ready awaiting her. The difficulties are great and require much patience and perseverance to overcome, and in fact remain as difficulties until two, three or four years of very uphill work have been passed through. A woman must work upwards to the higher branches of her art, and not be tempted by small profits to degrade it by undertaking cheap trumpery work with which to supply bazaar stalls; and to enter these higher branches she will need to have a very thorough Art education.

A very great mistake indeed is made by women when they think they can learn such an art as wood-carving in twelve lessons, and when they expect to earn money for work that is not worth either the wood or the time that they spend on it. Wood carving is like every other branch of science or art, and requires a great deal of time devoted to it; years not weeks are the apprenticeship it demands; and side by side with the actual practice must go the patient studying of many things quite separate from wood carving itself. Among the various branches of Art that should come within the wood carver's knowledge are architecture, the history of Art in its relation to general history, the grammar of ornament, the principles of design, artistic anatomy, geometrical drawing, outline drawing, modelling in clay; all these subjects are necessary to an accomplished wood carver, either man or woman.

As I have before said there is no opening for women among the lower grade of wood carvers; this class is already overfilled by men belonging to the artisan classes and working in the ordinary trade shops. I do not believe these shops will ever be open to women workers, and I do not think it is desirable that they should be. [The writer then describes the typical training of a boy as a wood carver and continues '... a woman who intends becoming a professional wood carver must start her career in a totally different fashion.']

First in importance is a firm resolve that her work is to be always first-class; not feeble and feminine, shielding its imperfections behind the plea that it is women's work, and therefore to have excuses made for it. If women are to enter into the field with men their work must be criticised by the same standard.

Here may I be allowed to enter a protest against exhibitions of women's work. If a woman's work be properly done it should not be distinguishable, in point of good workmanship, from the same work done by a man, where, therefore is the advantage in exhibiting it alone? There is no sex in art. Good work, whether it be man's or woman's, reaches the same high standard. [...]

A woman must recognise, from the first, that the choice of a profession entails a sacrifice. She cannot hope for much that makes up the life of a woman who is not working for a living. She must cultivate true business habits, and realise that she must never absent herself from her post, either as a worker or teacher, for such trivial reasons as small ailments or social calls. Work once forfeited in this way will not return, and in these days of strenuous competition it is easy to lose and difficult to gain.

3.3 Arts and Crafts Aesthetics and the Commercial World: Domestic Lighting

3.3.1 From: 'Domestic Lighting: the Work of W. A. S. Benson & Co. Limited' (Fig.11), an advertising supplement in *The British Home of Today* edited by W. Shaw Sparrow, London 1904, pp ix–xii

> *Considering its importance, both from a practical and a decorative standpoint, it is curious how little care is still devoted to the problems of house-lighting, and how often the position of lights (and even the choice of fittings) is left to persons whose tastes in the matter of furniture or hangings would be thought beneath consideration. [. . .]*
>
> *Mr. W. A. S. Benson, who made his name first twenty years ago as the reformer of oil-lamps and candelabra, which he redeemed from the bondage of early Victorian taste, served his apprentice-ship with Mr. Basil [Champneys], who warmly encouraged his ambition to make a fine art of artificial lighting. Mr. Benson has approached the problem from the standpoint of the architect rather than from that of the irresponsible designer of things pretty in themselves, but not necessarily in harmony with their surroundings, or properly adapted to practical use. When he began, the Morris movement, which has so profoundly influenced popular taste, was at its height, and both from sympathy and natural connection, Mr. Benson became associated with it. His metal work achieved as wide a reputation, in its own way, as the beautiful wall-papers and tapestries of William Morris. Since then, the firm in New Bond Street founded by Mr. Benson has applied itself successively to every branch of house-lighting; first to gas, with the old-fashioned flat flame burners; then to incandescent gas; next to acetylene; and finally to the admirable adaptations of gas-lighting provided by little inverted burners and mantles which seem to have given the older illuminant a fresh lease of life. [. . .]*
>
> *With regard to the design of fittings, Professor A. H. Church wrote many years ago, in the Portfolio, of Mr. Benson's work: "There are two features which call for remark in the simplest as well as the most elaborate patterns. One of these may be called constructional directness; the other, which indeed grows out of the first, is dignity of form." These two features are still characteristic of Mr. Benson's fittings in which ornament is used to emphasise, not to obscure the main lines of the design. Many of his fittings have no ornament, properly so-called, at all, but depend for effect on sheer beauty of line or mass, combined with the charm due to correct mechanical construction. For Mr. Benson is as good an engineer as he is an artist, and designs his fittings, whether rich or simple, with a direct view to their purpose and lasting properties.*

3.4 Workshops in the Cotswolds

3.4.1 From a Letter from Sidney Barnsley to Philip Webb, 6 July 1902

The architect Philip Webb was one of Morris's closest friends and associates.

He developed an almost fatherly friendship with Gimson and the Barnsleys and stayed with them in the Cotswolds on several occasions. This letter provides the background for the move of Gimson and the Barnsleys from Pinbury Park to Sapperton. It coincided with the marriages of both Gimson and Sidney Barnsley and a formal although short-lived partnership between Gimson and Ernest Barnsley designing and making furniture. The letter forms part of an archive on loan from Mr. G. Davies to CAGM.

You have indeed let yourself in for a trial by asking for news of 'Pinbury' life and I am afraid you will repent before finishing reading this. ... it is 12 months since I wrote to you and we have only heard indirectly of you and your doings during that time.

Well to begin with you will no doubt have heard of our leaving Pinbury, and probably some wildish tales. This is how it all came about – some 2 or 3 years since Lord Bathurst [2] spoke to my brother [3] about building a house for Lady Bathurst along the Leaves between Pinbury and Sapperton where they could spend some of the summer months and more particularly for their children to live and learn country ways – if possible? – this of course opened up very unpleasant possibilities for us having a big house blocking us from Sapperton and we also knew that they could never get anything as suitable as Pinbury and after long discussions we proposed to Bathurst that he should release us from Pinbury and provide sites and money for three cottages near Sapperton – this at first he wouldn't consider feeling it was too generous on our part and also no doubt fearing local gossip – (of which there has been plenty the poor Lady getting very much pulled about) so nothing further was said for 12 months when we had a letter from S. Helena where Bathurst was serving asking if we were still open to negotiate – and during that time many things had happened to make it more enticing to us so we said "Yes!" and we soon arranged all terms and naturally good for us – roughly we shall have 3 individual houses to our own tastes and fancies and upon better leases than at present paying the same rent as now and the whole of the money we have spent here refunded to us for spending again at Sapperton with the addition of a small present in cash! Then in addition we have Daneway House and farm buildings rent free for the remainder of our present lease – 11 years, to be used as workshops and the house for showrooms with the provision that if Bathurst should wish to let or use the house he will provide other suitable workshops for us. The land we have is a strip of pasture and wood land beginning in the site of the old house at Sapperton below the Church and going to the first division wall towards Pinbury about 1/3 mile – all exceedingly beautiful and ideal sites for smallish houses. As to Pinbury – so far all they propose doing – and they have put it into my Brother's hands – will be an improvement – the rebuilding of the wing at the back of the house built 60 years ago and making a big room for the shooting man! and joining Gimson's cottage by a passage way from the first floor of the house which is on the same level as Gimson's ground floor – and then the cottage will be for the sole use of the children and their governess.

My brother and Gimson have already started workshops at Daneway having 4 or 5 cabinet makers and boys so far, with the hope of chair makers and modellers in the near future. I am

remaining an outsider from this movement — still going on making furniture by myself and handing over to them any orders I cannot undertake, and orders seem to come in too quickly now as we are getting known.

The family life goes on just as when you were here, save that we are all growing older and I am afraid soberer, but we still manage to get a good deal of happiness and fun out of our life here.

3.4.2 From a letter from Sidney Barnsley to Philip Webb, 1 May 1904

This letter forms part of an archive on loan from Mr. G. Davies to CAGM.

We still live the same life that you knew at Pinbury, cooking and eating in the kitchen with the added luxury of a retiring room now, where we sit in the evenings and the children have their lessons, and in this way we have a sunny room all day. My workshop which I have to my 'lone self' is a great improvement upon the Pinbury one, much better lighted and being thatched is warmer and drier, and from the end window I have a most wonderful view across the valley to the hanging wood you would remember. I am still occupied principally in making good solid oak furniture with occasional pieces of a more delicate kind as a change and rest. I have just finished two tables of English oak, [4] *12' 0" by 3' 6" each, the tops out of 3" and with only one joint in the width and they have given me a fair dressing down and by night time I have felt fairly tired out. The man they are wanted for wanted the top 24' 0" by 3' 6" in the plank but I couldn't get it. Last week I heard of an old table in Glamorganshire 41' 8½" by 2' 9" by 6" in one piece!!*

3.4.3 From a letter from Ernest Gimson to his elder brother, Sydney, 12 February 1903

These letters are part of the Arts and Crafts archives, CAGM.

The store cabinet [5] *in the Arts & Crafts took 839 hours to make (Fig. 12). Yours took 443 hours. The A & C one too is fitted with more expensive wood (very expensive as it cost 2s/6d a foot ⅟₁₆ inch thick.) New the gesso panels cost £1 each. That makes the difference in the two prices. Yours to have paid properly should have been £34. 9. 1½ but we didn't do our estimating properly you see. Now I have all the responsibility* [6] *on my sloping shoulders I expect to develop a keener eye for small profits. By next Christmas we shall see whether I be fool or no. It should do me good in time and give me some extra 'crushing strength'! You shall take your £1 share when I have grown my business aptitude.*

3.4.4 Letter from Ernest Gimson to Sydney Gimson, 6 May 1904

Thanks for your letter. I wish too that it were possible to scramble along without selling so many of G & Co. shares. [7] *But how else can capital be found?*

For my first innocent calculations as to capital required no allowance was made for money
owing or for the value of the uncompleted work in the shop. At the present time these two items
come to £500. Besides this I should like to have a balance of about £200 in the bank.

This is how my capital has gone	£
Repairing Daneway & turning farm buildings into shops	250
Shop fittings	75
Furniture in stock	650
Stock of locks, handles etc. etc.	50
Seasoned timber	200
Timber seasoning	450
Furniture in workshop	150
„ delivered & not paid for	350
Capital for Blacksmiths shop	100
„ for Chairmaker	25
	£2300

and then there is the balance of £200 that there should be in the bank making £2500 in all. So
far I have been able to pay the interest on capital from my personal earnings apart from Daneway.
You see that I am anxious that you should not think the shares would be sold recklessly.
I should be very glad of the £150 advance from the firm.

3.4.5 From 'Notes of the Month', a review of Ernest Gimson's exhibition
at Debenham and Freebody's department store, *Architectural Review* Vol.23
February 1908, p.102

Ernest Debenham had been a friend of Ashbee's at King's College, Cambridge and
at Toynbee Hall and was a long-term supporter of the Arts and Crafts. In 1907 he
opened a luxurious new department store, Debenham and Freebody's, in Wigmore
Street, London which included plasterwork friezes and ceilings designed by Gimson.
At the end of the year, he was also offered the opportunity of an exhibition on the
first and second floor landings of the store, an unusual venue for Arts and Crafts
shows. Eighty items were displayed including metalwork and turned chairs as well
as furniture, and a catalogue was produced.

The work of Mr. Ernest W. Gimson is always interesting, even if its motives seem sometimes rather
bald, and the exhibition of furniture and ironwork recently held at Messrs. Debenham & Freebody's
gave a very welcome opportunity of seeing it in the mass, and not in a few pieces only, as at an
Arts and Crafts Exhibition.

We can scarcely give higher praise than to say that Mr Gimson's furniture comes successfully through the ordeal of a "one-man show."

It was a notable feature of the last Arts and Crafts Exhibition that many of the furniture makers had so entirely shed the early eccentricities of the revival in furniture design, that some of their work was almost indistinguishable from copies of "period" furniture. Mr. Gimson has, however, maintained his individuality very markedly, and while avoiding vagaries, owes little to the historic English styles. Out of some seventy pieces exhibited only two in unpolished oak have the heavy wooden handles, chip-carved, which were so greatly in vogue some five years ago. The metal fittings are particularly delicate, and in particular the little T handles used for small cabinet drawers are a lesson in refinement. Mr. Gimson delights in strong colour contrasts; the pale mahogany cupboards on black bases are emphatic but admirable; occasionally the effect is a little garish, but on the whole the mixing of woods shows great judgement. The chairs, &c., in turned ash are simple and straightforward work, but it is in the treatment of large flat surfaces with veneer of sumptuous figure that Mr. Gimson excels. With inlay he is either very economical, using it just to enliven a piece in which the figure of the wood does not play a large part, or lavish in covering the whole surface of small boxes. Economy is, however, the prevailing note, and refreshing it is after the sickening profusion of wide satin-wood bands beloved of mahogany users in Tottenham Court Road. [. . .]

On the important question of price, our impression is that the simpler oak things are slightly expensive, and those in more expensive woods very cheap, but in no case are the prices higher than are ordinarily and properly asked for well-made cabinet work.

3.4.6 From a letter from Ernest Gimson to Philip Webb, 23 December 1907

Webb's comments to Gimson after visiting the exhibition have not survived, but he appears to have criticised the design of the cabinet [Fig.13]. This letter is part of a collection in the Arts and Crafts archives, CAGM.

Dear Webb,

I was glad to have your letter with its helpful appreciation & criticism . . . I quite understand what you mean [about] the want of some sort of cresting to the walnut cabinet – at least I think I do. But this is a dovetail jointed thing, & any sort of projection would have to be quite apart from the construction, & although it might somewhat mitigate the uncompromising severity of its expression, it might also, don't you think, lessen the interest in its character.

It is astonishing how my joiners grumble when they are asked to make a projecting top with the mortice & tennon or slip dovetail construction (dowels are not allowed). The cabinet we are talking about was originally drawn with four posts tennoned into a thick projecting top but my good foreman would take no pleasure in making it till I had changed it to its present bald outline. For my part I like it either way & the nicely fitting dovetail is compensation for lack of a capping. [. . .]

Yes, my young men are capital chair rushers now & get quite a lot of work to do. Each does the whole chair from start to finish & has about a dozen patterns at his finger ends. Here we are often content to be simply copyists. Some of the old patterns are so admirable — good country work with no thought of style — that the making of them is pleasure enough. [...]

The fire-dogs were made by the young village smith and were pierced and chased on his anvil. My smiths all think such things rather trivial & are much happier with their forges & hammers — as who wouldn't be!

3.5 The Guild of Handicraft in Chipping Campden, 1902–08

3.5.1 From 'A Workshop Paradise in the Cotswolds' by Charles Rowley, in
A Workshop Paradise and Other Papers, Sherratt & Hughes, Manchester 1905, pp 2–5, 6

Charles Rowley (1840–1933) was a socialist and a promoter of education in Manchester. He arranged for the Pre-Raphaelite artist, Ford Madox Brown, to paint the murals in Manchester Town Hall and his friendship with William Morris brought him into contact with many Arts and Crafts designers. He chaired the committee of the School of Art when it was taken into municipal control in 1892 and brought Walter Crane to Manchester as its Director of Design with the express intention of introducing Arts and Crafts ideas. Both men were involved in the establishment of a museum and in collecting contemporary work for its collection from 1894.

Ashbee encouraged visitors to the Guild of Handicraft in Chipping Campden; Braithwaite House on the High Street, where some of the unmarried Guildsmen lodged, also had a number of guest rooms provided. This piece first appeared in the *Manchester Guardian and City News*.

Some twenty years ago, in my early visits to Toynbee Hall, I saw the garret workshop where some dozen young fellows were doing varied woodwork at their simple benches. These classes were under the care of Mr. C. R. Ashbee, a graduate of Oxford [sic], and an architect by profession. Soon after this, under the same excellent guidance, a further step was taken by renting a fine old house at Bow, still further east than Toynbee. Here, in Essex House, was developed those varied handicrafts whose fruit soon attained note at Arts and Crafts exhibitions, and among such purchasers as had an instinct for good non-trady workmanship, and who knew good designs from bad. It was simply by having a man with some persistency, a remarkable capability for varied crafts, and above all a high ideal, that lifted the amateur movement into a guild of handicraft, which conscientiously produced the best work of its class.

A real Guild was formed, each worker to have a share and a pride in it. "The Guild seeks not only to set a higher standard of craftsmanship, but at the same time and in so doing to protect the status of the craftsman. To this end it endeavours to steer a mean between the independence of the

artist – which is individualistic and often parasitical – and the trade shop, where the workman is bound to purely commercial and antiquated traditions, and has, as a rule, neither stake in the business, nor any interest beyond his work-wage." The men and women workers have a share in the concern and a voice in its government.

A few years ago a bold step was taken. The workfolk and all their establishments were induced to flit from east London to Chipping Campden. A change more drastic can hardly be imagined; yet when I saw the workshops recently one could readily imagine they were native to the place. An old mill with a ground and upper storey lends itself to handicraft workshops of this nature. Every window looks on to a lovely common garden, every bench has a posy on it. Nothing could be more delightful than to be doing rationally good work in such surroundings.

My friend Mr Ashbee being on a holiday, I was entertained by the manager, Mr. Osborn. My first question in such cases is the prosaic one, "Does it pay?" One knows that philanthropic fidfaddery neither pays nor produces anything worth having. Yes it pays. The work is sound, unique in design, well-done all round, and not too expensive. The Guild is perhaps best known for its production of personal ornaments, brooches, necklets, casquets, and the like. But the larger side of the decorative arts is not neglected. There is a good smithy, where the finest ironwork is done. I saw some noble wood-carving for a nobleman's library. Architectural work of all kinds is carried out, from structure to furnishing. "We begin to think," says Mr. Ashbee, "that it is not necessary to look any longer to the great towns, least of all to London, as centres of life, inspiration, or education; and that a little Cotswold village will probably be found to possess many other things that make for the building up of character and the good craftsmanship which is its expression. We at least intend to try, and we look into the future with hope and confidence." [...]

It is not every industry that can be so conducted. But surely there are many that would be all the better to be done in sweet, pure air, surrounded by beauty, and where peace and quietness must tend to improve the wonder and the work. There is no mistake that all the sixty or seventy members of the Guild look happy enough, either in the smithy, the carpenter's shop, the printing rooms, or the jewellers' benches. Why not? All were sensibly occupied in doing work worth doing and were taking delight in it. One wonders how much of the work done by the seven millions of us on the coal-beds hereabouts in Lancashire and the West Riding will be treasured by the next generation some thirty years hence. But there is no doubt that most of the work of the Guild of Handicraft at Chipping Campden, in rural Gloucestershire, will be valued for its own sake, for it is pure in form, sound in material, and is not a make-shift for a season or a fashion.

3.6 C. R. Ashbee: On Arts and Crafts Education

3.6.1 From *On the Need for the Establishment of Country Schools of Arts & Crafts* by C. R. Ashbee, Chipping Campden 1906, pp 2–5, 11

Education was at the heart of Ashbee's work and in this pamphlet he re-emphasised

the connection between the Arts and Crafts and society, writing: 'The art we have by modern education to find is, as it always has been, the art of life; and to build well or to do anything else well, means first and foremost that we must well live.' [8] The move from London to Chipping Campden gave him the opportunity to re-establish the educational arm of the Guild of Handicraft. In 1904 the Campden School of Arts and Crafts was opened with a grant for technical education from Gloucestershire County Council. He was devastated when the school was forced to close in 1916 because the grant was withdrawn. This extract was first published as a chapter in *A Book of Cottages and Little Houses* by C. R. Ashbee, Chipping Campden 1906 (Fig.14). Its concurrent reprint as a pamphlet indicates the significance attached to it by Ashbee.

Often has it been insisted that all social reconstruction, like the serpent devouring its own tail, begins and ends with education. We cannot give good education until we have citizens sufficiently intelligent to see the need of it: we cannot attain to a high ideal of citizenship until we educate. Or, looking at the circle from the other side, we cannot give work to the unemployed because he is unemployable; he is unemployable because we have never rightly educated him to work. Education and workshop reconstruction must proceed side by side. Now there are three conditions for a well educated life, and they are these — health, joyousness or interest in our work, and good citizenship. […]

I would plead for good country building as the expression of practical needs in life. I would plead for the human quality in it and for the checking and limitation of waste, the waste particularly of machine production. I would plead for tradition, for its reverent regard in old work, and its carrying on into the new work we have yet to do. I would plead for an awakened understanding among landlords & country builders of these questions that affect the craft, and for an intelligent examination of their economic significance. And finally, I would plead for a definite study of the right and wrong in machine production — for the treatment of the machine as an ethical, not merely an economic, problem. […]

We cannot reconstruct the old workshop system, but we can adapt what remains of it to modern conditions and use it as part of our educational material to work upon. In every place of over 500 inhabitants there is almost certainly a blacksmith, a builder, a carpenter, perhaps a plumber, perhaps a few other crafts; there are certainly labourers & boys of no training; there are constant repairs and object lessons in construction to hand; there are long winter evenings unemployed. It should be the object of our village schools of craft to get hold of these fellows, to observe these local needs, to employ these vacant hours. […]

I think we should set before ourselves a four-fold objective, and it is this. We should, in the first place, get into direct touch with local wants. We should, in the second place, be frankly experimental, always trying something new and testing ever the changing value of old methods. We should, thirdly, teach citizenship, making this a definite end and giving all our practical & technical subjects a bearing upon it. We should, fourthly, make the last object of our study the ethics of production. […]

In short, we have to diagnose the good and bad, the right and wrong, in the things we make and handle; the problem of the ethics of production is the ultimate problem of our schools of art and craft.

3.7 C. R. Ashbee: On Town versus Country

3.7.1 Extract from *Craftsmanship in Competitive Industry* by C. R. Ashbee, Essex House Press, London and Chipping Campden 1908, pp 41–5

This book was produced just as the Guild of Handicraft ceased to exist as a limited Company. Ashbee's poignant dedication read: 'To those Members of the Guild of Handicraft, who, whether working in the Guild's Shops or not, have decided to stick to it and see it through.' Ashbee used the book to restate his philosophy:

> *What I seek to show is that this Arts and Crafts movement, which began with the earnestness of the Pre-Raphaelite painters, the prophetic enthusiasm of Ruskin and the titanic energy of Morris, is not what the public has thought it to be, or is seeking to make it; a nursery for luxuries, a hothouse for the production of mere trivialities and useless things for the rich. It is a movement for the stamping out of such things by sound production on the one hand, & the inevitable regulation of machine production and cheap labour on the other. My thesis is that the expensive superfluity and the cheap superfluity are one and the same thing, equally useless, equally wasteful, & that both must be destroyed. The Arts and Crafts movement then, if it means anything, means Standard, whether of work or of life, the protection of Standard, whether in the product or in the producer, and it means that these two things must be taken together.* [9]

He also reassessed the purpose behind the Guild of Handicraft's move to the Cotswolds.

> *It will be evident ... to the most superficial observer that the condition of any Arts and Crafts business if it seeks to stand on its own merits alone, must, under modern competitive conditions, be precarious. Even in the great town — that hot-house of exotics — its condition will remain an artificial one. <u>And</u> yet perhaps no more artificial than any of the great Industrial undertakings which depend not upon the real or permanent needs of the Community, but upon needs which are forced upon it by artificial or insecure conditions — soap for instance, the demand for which rests largely upon soot, and the filth of our great cities; or corrugated iron, the demand for which is a result of the general insecurity and unwillingness to use permanent building materials.*
>
> *In the town we had not only the market at the door, we could draw from the best East London schools for our young apprentices, and from the best shops for our skilled workmen, we*

could watch closely the work of our colleagues and competitors, we had the South Kensington Museum as a source of inspiration, and we had trains and 'buses to take us there. We also had trains to take us out of the town for week ends, and the little country cottages we set up first at South Benfleet in Essex, then at Ruislip in Middlesex, Long Crendon in Buckinghamshire, and Drayton-St.-Leonards in Oxfordshire, helped no little to unite our people and give us the right taste for the country.

I seem to see in the prevalent fashion of the week end cottage the beginning of that decentralization of industry which is to destroy the great town. Not a few of the little Arts and Crafts in this way have gone into the country, and perhaps in this way may come our second retort to the business man's "I told you so!"

We felt indeed long before the move was made that to do our work of Arts and Crafts well we must get out into the country. For two years before the expiry of our lease at Essex House, we searched in the great town to see whether we could find there a suitable place for our new workshops. We tried Mile End and Bow, South Benfleet and the eastern districts, we tried Fulham & Chelsea and Putney and Brompton, we went north & tried Ruislip and Harrow. None of these for one reason or another seemed good enough, until we went right out into the little forgotten Cotswold town of the Age of Arts and Crafts where industrialism had never touched, where there was an old silk mill and empty cottages ready to hand, left almost as when the Arts and Crafts ended in the 18th century. Perhaps this historical or — is it sociological — expression of English life may yet give us the key to their development in the future.

The very fact, however, that the week-end stimulus is needed, that the museum and the technical school are not enough, that somehow we cannot do without country air and that all these other aids to life are required to make it possible for the Arts and Crafts to prosper in the great city, shows how artificial their whole condition is, and how we must ultimately look for some other basis upon which to set them if we wish them to be secure. What these may be I shall examine in later chapters. Here I wish to state my conviction that though in the great town they may for the time being be economically possible, they cannot there under modern conditions have any abiding home. Those of us who have for many years lived and worked in the eastern quarters of the great city, know only too well that for national character, for constructive purpose, for stable creation, something better is needed than the environment of an "East End," whether it be on the south side of the Thames or the north, whether it be in Birmingham or in Sheffield, in Wolverhampton or in Glasgow, in Pittsburg or in Chicago. I have had 15 years of it in the worst parts of London, and so perhaps know. My experience indeed has been full of happiness, largely due no doubt, as it is with others, to persistently shutting my eyes ; but, much as I like the East London cockney, his vivacity, his imaginative romance, his effervescent humour, his loyalty and affection, and the quality in him that is perpetually driving nervously for something new ; much as I love him for these things, the great town which engenders him deprives him also of other qualities that are needful for the work I would see him do. Repose, margin, leisure, reserve, restraint, and colour in life, these other things are also wanted for the Arts and Crafts, and these other things are better found in country surroundings where there are green fields, and trees and beauty, where there is chance for good physical develop-

ment, where there is no soot, no oppressive ugliness, and no daily nervous racket of locomotion to and from work.

When ... I put myself the question in the light of the last six years' experience in the country — was the thing worth permanent doing in the town, and would you for the sake of economic success have continued it or start it again, I answer, No. The thing was not worth permanently doing in the town, what we gained in economic success we paid for in the human something that has given to the best of our later productions their quality, and to our workmen their character. Also we have gained by what we have done a certain finer outlook into life that has influenced all of us and our work. It would be comparatively easy with the experience of 20 years behind us to go back to London and start it all again — a new Guild of Handicraft in East London or elsewhere, many of its old members would return to it even there, but many would not, because they have seen how things can be better done; and some of us feel with Socrates that having once seen the Sun and learned the meaning of the shadows on the wall, we have no desire to go back to the den.

3.8 Restating the Values of the Movement, 1905

3.8.1 From *The Arts and Crafts Movement* by T. J. Cobden-Sanderson, Doves Press, London 1905, pp 3–4, 29–30, 38

The Movement passing under the name of 'Arts and Crafts' admits of many definitions. It may be associated with the movement of ideas, characteristic of the close of the last century, and be defined to be an effort to bring it under the influence of art as the supreme mode in which human activity of all kinds expresses itself at its highest and best; in which case the so-called 'Arts and Crafts Exhibitions' would be but a symbolic presentment of a whole by a part, itself incapable of presentment: or it may be associated with the revival, by a few artists, of hand-craft as opposed to machine-craft, and be defined to be the insistence on the worth of man's hand, a unique tool in danger of being lost, in the substitution for it of highly organized and intricate machinery, or of emotional as distinguished from merely skilled and technical labour: or again, it may be defined to be both the one and the other, and to have a wider scope than either; as for example, it may be defined to constitute a movement to bring all the activities of the human spirit under the influence of one idea, the idea that life is creation, and should be creative in modes of art, & that this creation should extend to all the ideas of science and of social organization, to all the ideas and habits begotten of a grandiose and consciously conceived procession of humanity, out of nothing and nowhere, into everything and everywhere, as well as to the merely instrumental occupations thereof at any particular moment. [...]

An exhibition ... is but a small part of the Arts & Crafts movement, which is a movement in the main of ideas and not of objets d'art, & there is a danger in the constant repetition of exhibitions, civic, national, and international, of public attention being diverted

from the movement of ideas, & action thereupon, to the mere production and exhibition of
exhibits. [. . .]

As of the world of man's work, so of all the visions within the vision – build with the
instincts of fitness and beauty, build & await the Shadow: to-day again, for a time, comes the
light, again and yet again.

3.9 Craftsmanship and Design

Three extracts from *The Arts Connected with Building* edited by T. Raffles Davison
(1853–1937), Batsford, London 1909.

This book consists of a series of lectures on craftsmanship and design first delivered
at Carpenter's Hall, London Wall for the Worshipful Company of Carpenters by
some of the leading architects and furniture designers of the day including Guy
Dawber (1861–1938), Robert Weir Schultz (1861–1951), Charles Spooner
(1862–1938) and M. H. Baillie Scott in addition to the writers below.

3.9.1 From 'The Influence of Material on Design in Woodwork' by Francis Troup
in *The Arts Connected with Building*, pp 74–6

Generally speaking, you ought to be able to tell from its appearance if a well-designed thing is made
of soft or hard wood, whether the object has been painted or not. . . . the tool suitable for one wood
cannot be used for another without modification of some sort. The draw-knife is a delightful tool
for oak, ash, or chestnut, as you may see in hundreds of waggons and carts in the London streets,
or better still, in Covent Garden Market, but you could do nothing with it on ebony; you might as
well try and chamfer off the edge of a block of Bath stone with the draw-knife. You can get the same
form and shape wrought in ebony and iron-wood by other means, but then the shape is not natural
to the material, nor would it have ever been done by the unsophisticated craftsman left to his own
traditions, although, none the less, the result may be a sufficiently beautiful model in itself, if you
can bring yourself to look at it in that way. This, however, is one of the first pit-falls that has to be
avoided by the modern type of what we may call "Paper designer." Unless he has actually practised
at the bench, and is familiar with the acknowledged methods of the skilled craftsman, he must devote
himself to find out which are the proper tools, and how far they are suitable to the material in hand.
Nor must he overlook machinery. If machine tools are legitimately used they form an excellent
servant, but there must be no imitation "handwork" about them. A genuine labour-saving machine
is a perfect godsend if it be properly used, and, in fact, kept in its proper place, though I confess
more than a sneaking admiration for the craftsman who deliberately undertakes sawing up his
planks by hand in order to have a rest from the hard thinking needed for other parts of his work.

3.9.2 From 'The Influence of Tools on Design' by A. Romney Green
in *The Arts Connected with Building*, pp 92–4

Arthur Romney Green (1872–1945) gave up a career as a teacher of mathematics
in 1900 to make furniture. He set up a number of workshops before settling in
1919 in Christchurch, Hampshire. He was inspired by Morris's ideas about art
and life – like him Green was a poet and wrote about the crafts and social reform
– and he seems to have had the ability to combine all his interests to enrich his life
and work.

Just as the hand-cut moulding is more interesting than that which has been cut with a moulding-plane, so the adzed beam following the lines of the tree, and with that play of light on the tool-marks which is almost better than conscious ornament, is infinitely more interesting, both in form and surface, than that which has been machine-sawn and planed, and which has not even the only merit it pretends to, of being really smooth and well finished, since even a really smooth finish can only be got by hand.... The work may sometimes become more perfect in the structural or mechanical sense; but whether or not it becomes less beautiful, it always becomes less interesting, less human and alive. It becomes less interesting partly because the interest is absorbed by the tools – because our time and thought and creative genius are exhausted by these before we come to the finished work, so that our tools and machines, our means of production, are much more truly works of art than our finished products; and partly because these tools and machines are often abused either wantonly or for the sake of economy. [...]

But the use of machinery has a further indirect effect upon our modern design, which is in the nature of a reaction; which is seen in the almost morbid desire of the craftsman or designer to be as original as he possibly can. He gets so tired of the monotonous repetitions of the machine, and, rightly or wrongly, he imagines that the public must get so tired of them that he determines, whether he is a so-called craftsman or whether he is himself a designer of this wholesale work, to do something quite new and as different from the last wholesale fashion as he possibly can. And so we get a series of monotonous repetitions of one lifeless and monstrous type, and then a series of another quite different type, equally monstrous and lifeless; or we go to an art and crafts exhibition, and see a number of individual monstrosties, such as I have myself too often been guilty of: tables that seem to be brandishing their legs in the air, or chairs that remind us of that rare specimen of a cocka-tricycle that was once found at the bottom of a very steep lane in Devonshire. And this great divergence and variety of types or species, and this monotonous similarity of the individual examples of each species are alike unnatural – alike bear witness to the absence amongst us of any living and natural tradition. When there is such a living tradition, you have neither this wide divergence of types nor this exact similarity of individual samples; there will be a class of tables, for instance, of a given period, which are like leaves of the same tree, all nearly, but no two exactly alike; another class of tables or a class of chairs, like leaves of another tree of the same climate, and so on; and the types of one period grow out of the types of the previous period, just as the natural

species of one geological era grow out of those of the era preceding that, and almost as slowly, as
I have shown you in the case of Norwegian woodwork.

3.9.3 From: 'Ideas in Things' by C. F. A. Voysey in *The Arts Connected with Building*,
pp 103, 104–8

C. F. A. Voysey developed his ideas about design and its importance to every aspect
of life in numerous articles and books.

This age we live in is intensely material; it has witnessed a mighty development in material things.
The steam engine and electricity have transformed the world; our minds have been engrossed by
material ideas to such an extent that we have scarcely devoted that attention to the spiritual side of
our natures which that side deserves. [. . .]

Our nature has always been twofold, viz, material and spiritual. And it is only common-sense
to recognise this dual quality. We must distinguish between those things which help to develop the
body and those which lead to the purification and advancement of the character. [. . .]

Not for one moment would I belittle the importance of all material and bodily conditions.
But in the cause of art and the higher qualities of man, we must pay more regard to the spirit
and less to the flesh without which spiritual basis no art is worth having at all. [. . .]

The presence of so much ugliness in our life to-day is largely due to our materialist habit of
mind. We love ease far more than beauty, utility far more than inspiration; and consequently, "ideas
in things" are not readily recognised. Before going further, it is necessary to draw clear distinction in
our minds between associated ideas and intrinsic ideas. For instance, some have the idea that money
is the root of all evil. This is an associated idea, due, we think, to false reasoning. It is by the bad
way in which money is used that evil is caused. [. . .]

All art is the expression or manifestation of thought and feeling; therefore a technical knowledge
of any craft by itself is but a language with which to express thought and feeling. And such qualities
of mind as accuracy, order, neatness, precision, frankness, love of truth, and, above all, reverence,
are some of the qualities of mind we call spiritual because they minister to our characters far more
than to our bodily comfort. We may make doors and windows, chairs and tables with mechanical
exactness, and be paid in coin in exchange, but neither we nor those who pay for it will gain any
spiritual benefit from our labour unless we have put our heart and minds into our work, anxiously
seeking to impart some good thought and healthy feeling. [. . .]

Once let it be recognised that the spiritual verities are of primary importance, and that we can
help on our own as well as our neighbours' growth in virtue by trying to put thought and feeling
onto our work, we shall then find an added joy in labour far more precious than any material
reward … We are all endowed with the power to impart thought and feeling. All we need to
acquire is the power to discriminate between good and noble thought and feeling and the baser sort.
What have our schools done in this direction? What are they now doing? Many of them are teaching

us that in certain past ages very beautiful work was done, and that such beauty is not possible to this dark age ... My friends, this is false teaching. There is as much capacity for goodness to-day as there ever was in any age. Men can turn out work as perfect in all material qualities as the world has yet seen. [...]

The human quality in familiar objects has in many cases been driven out by the machine. Nevertheless, the machine has come to liberate men's minds for more intellectual work than was provided for them by the sawpit, though still there is much work in the world which requires little or no intelligence ... Let us remember the sense of duty is yet left to us; and thousands will bear witness to the fact that the sense of duty has often transformed irksome tasks into pleasant labours. But besides the comforting thought that the unpleasant labour is a duty, we shall find that many dull occupations may be made enjoyable by instilling spiritual qualities into them. Conscientiousness and a love of truth and hatred of all forms of deception will help us to make the hidden parts of our work as good as those that are seen. I do not think there is one here present who would not enjoy making articles of furniture of one quality throughout, instead of oak in front and deal behind. And our patrons, if they, too, felt the same, would be glad to pay for the absence of sham. If we would frankly acknowledge the structural necessity of nailing down our floor-boards, we should not strain our ingenuity in devising methods of secret nailing. We are far too keen on mechanical perfection. That love of smooth, polished surfaces is very materialistic; it can be produced without brains, and in most cases can only be produced by the elimination of all human thought and feeling. It is delightful to see skill of hand and eye. All evidence of painstaking is a joy to behold. But in our materialism we have run after the perfection of the machine and preferred it to the perfection of the human heart. [...]

I would not have you go back to all methods of hand labour and neglect the aid of the machine. All we need is to recognise its material value, and its spiritual imperfection, and put into all our hand-work that thought and feeling which is the breath of life. The worker and the worked-for all alike must co-operate to instil new life into all they make by dwelling on the moral and spiritual significance of things.

Notes

1 Editor's preface from Johnson, E., *Writing and Illuminating, and Lettering*, John Hogg, London 1906, second edition 1908, p.vii.

2 Lord Bathurst owned extensive estates in the Cotswolds around Cirencester including Pinbury Park, Daneway House, a large fourteenth-century house by the canal below Sapperton, and the village itself.

3 Ernest Barnsley.

4 The tables were commissioned by the fourth Marquess of Bute for the Old Place of Mochrum, Wigtownshire, Scotland via his architect, Robert Weir Schultz.

5 This cabinet (w.27.1977) is now in the collections of the Victoria and Albert Museum, London.

6 This refers to the break up of the partnership between Gimson and Ernest Barnsley. It was an acrimonious split caused partly by business and personality differences.

7 Gimson and Company, the engineering firm in Leicester set up by Gimson's father Josiah Gimson.

8 Ashbee, C. R. *On the Need for the Establishment of Country Schools of Arts & Crafts*, Chipping Campden 1906, p.I.

9 Ashbee, C. R. *Craftsmanship in Competitive Industry*, Essex House Press, London and Chipping Campden, p.9.

Fig.1 William Morris's first attempt at wood engraving in seventeen years in January 1891 following the establishment of the Kelmscott Press.

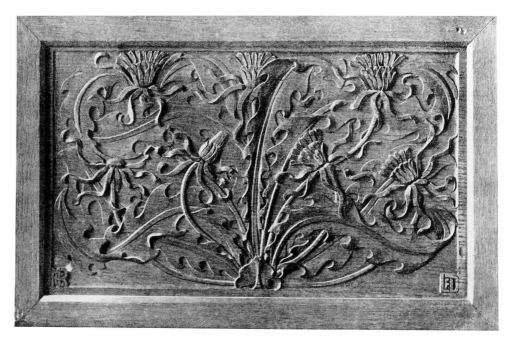

Fig.2 Photograph of 'Dandelion' panel in oak by Lewis F. Day from an exhibition
at the School of Wood Carving, South Kensington, London, 1905.

OPPOSITE
Fig.3 A page from W. R. Lethaby's essay on 'Cabinet Making' from *Plain Handicrafts*,
edited by A. H. Mackmurdo, 1892.

we want them. The bench serves better at the table; and by the fire we can have a settle with a high back, or a large armchair, which we may make something like Fig. 11. Keep the seat low, and deep from back to front; let it also be thicker, and curved at the front, as shown by A on the drawing.

Now, we want a cupboard or dresser. Fig. 12 may serve

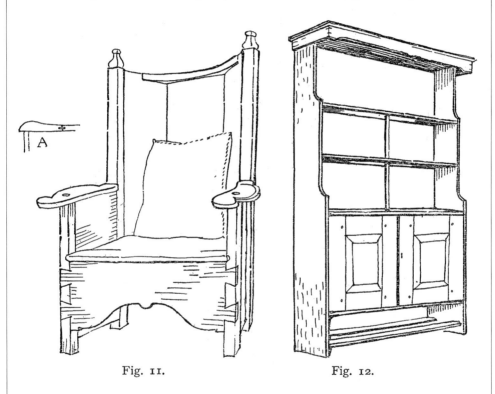

Fig. 11. Fig. 12.

as a pattern. The ends are solid; the shelves have fillets along the front edge with hooks for cups and jugs, while the doors below are panelled.

I give, last of all, some profiles of mouldings. The top row shows such forms as are usually combined for cornices, the second group shows shelves and cappings, and the third plinths, while those in the bottom row are panel mouldings.

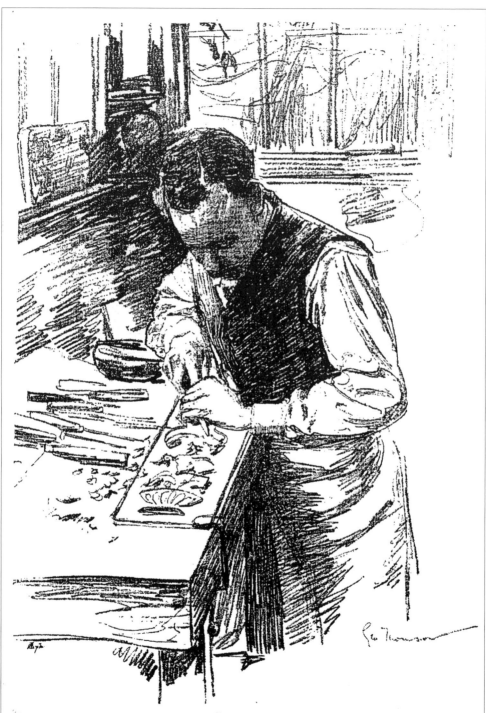

"WOOD-CARVING AT ESSEX HOUSE" DRAWN BY GEORGE THOMSON

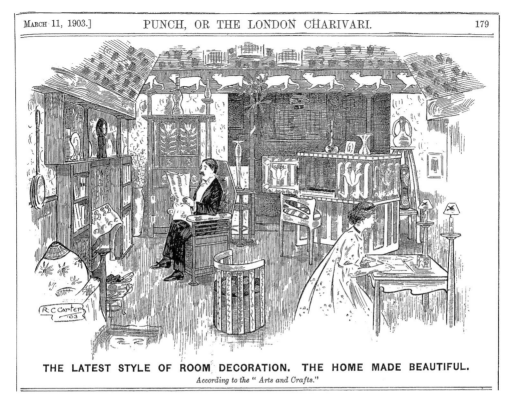

THE LATEST STYLE OF ROOM DECORATION. THE HOME MADE BEAUTIFUL.
According to the " Arts and Crafts."

Fig.5 'The Latest Style of Room Decoration. The Home Made Beautiful. According to the "Arts and Crafts"' a *Punch* cartoon by R. C. Carter, 11 March 1903. This gentle satire on the work of M. H. Baillie Scott features the architect himself as the seated male. The stencilled frieze of Manx cats refers to his Isle of Man roots and the barrel chair and the Manxman piano are all clearly his work.

OPPOSITE

Fig.4 One of the Guild of Handicraft wood carvers illustrated by George Thomson in *The Studio*, April 1897.

Fig.6 Two versions of a bookplate designed by Ernest Gimson for his elder brother,
Sydney Ansell Gimson, 1898. The bottom version was the one used.

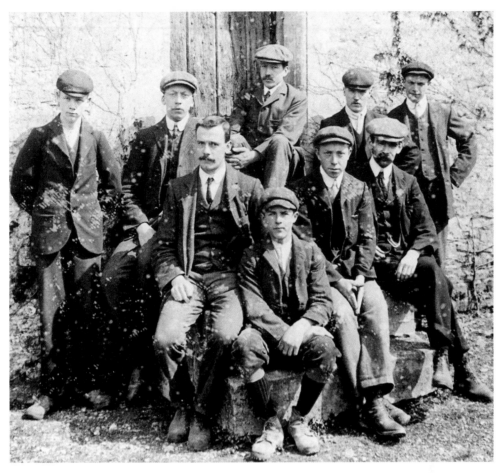

Fig.7 Ernest Gimson, seated centre back, and his workmen at Daneway, Gloucestershire, *c*.1902.
The foreman, Peter Waals, is third from left; the young local blacksmith, Alfred Bucknell is sitting
next to him. The cabinet maker, Harry Davoll, is second from right.

Fig.8 From left to right: Arthur Cameron, an unidentified man and John Cameron, both metalworkers with the Guild of Handicraft, behind the Catholic church, Chipping Campden, about 1904.

OPPOSITE

Fig.9 Explanatory note from *The Artistic Crafts Series: School Copies and Examples*, selected by W. R. Lethaby and A. H. Christie and published by John Hogg, London, 1904 in conjunction with the series of technical handbooks. The image is a woodcut of a tiger by Thomas Bewick from *A General History of Quadropeds*, 1790.

An Explanatory Note on the Series

IN this Series it is intended to make available for School Purposes fine Works of Art in facsimile, and also to bring together Examples carefully chosen as being Educational and Suggestive. It has been too much the habit in Drawing-copies to sacrifice the Beauty of the Example to some theory of method in instruction, as balance, clearness of outline, and so on. It is our purpose, on the other hand, to put fine, suggestive, and useful material before the Student, so that he may at once have Drawing-copies of a real kind, Standards of Excellence, and Examples of Historical Art, which should stir his Imagination and suggest the very Purpose of Art. It is possible, by modern photographic methods, to give facsimile enlargements from such things as Bewick's superb woodcuts of Animals and Birds, and from the finest Italian prints of the XVth and XVIth centuries. Together with such examples, we intend to give Standard Alphabets, Coats of Arms, and Specimens of Ornament; also Collections of Patterns for Silver-workers, Wood-carvers, Bookbinders and others, in separate parts.

In copying the drawing examples, we would suggest that various methods should be made use of, sometimes the line for line copy of the whole, sometimes a study of a part with great care, sometimes a freer rendering, the copy being placed at a distance from the student or group of students.

We make no apology for the "roughness" of some of the enlargements from master works, for their authenticity is to be valued much more than if the plates had been meddled with.

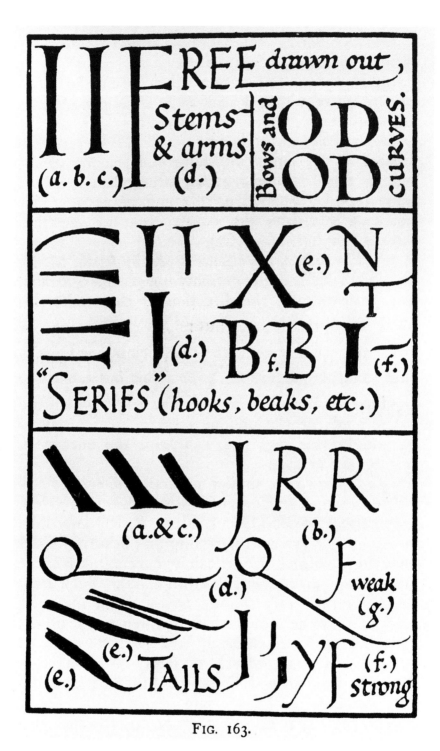

FIG. 163.

Fig.10 An illustration from the chapter on 'The Roman Alphabet and its Derivatives' in *Writing and Illuminating, and Lettering* by Edward Johnston, 1906.

Domestic Lighting

The Work of W. A. S. Benson & Co. Limited

Considering its importance, both from a practical and a decorative standpoint, it is curious how little care is still devoted to the problems of house-lighting, and how often the position of lights (and even the choice of fittings) is left to persons whose tastes in the matter of furniture or hangings would be thought beneath consideration. To some extent, that bane of insurance offices, the "ready-wired" house may be responsible for bad practice in the arrangement of lights ; but it is also quite a common custom to hand over the scheme of lighting to a builder, a paper-hanger, a gas-fitter, or even a plumber, as if personal interest in this branch of work was unnecessary. Nothing could be more disastrous.

BENSON ELECTRIC TABLE LAMP, with mod-lled base and "Ceonix" glass shade.

TABLE-CENTRE ELECTRIC LAMP.

(in the case of electric light) and expense, and even of risk. are placed at random, after is a misery to live in. On conducive to comfort as a the lights have been properly gives a more signal air of graceful and simple light fit- style to suit the rooms. any particular space is deter- by its proportion, arrange- and by the nature of its use. etc., of the lamps should be good light is provided in or writing, the whole space modulation and gradation artistic effect. To obtain

A badly wired house is a constant source of trouble A house in which the lights the ordinary gas-fitter's ideas, the other hand, nothing is so house where the positions of thought out, and nothing distinction to a house than tings designed in scale and

The proper lighting of mined not only by size, but ment, and decoration as well, The number, power, position, contrived so that whilst a likely positions for reading is pleasantly lighted, with that which are indispensable to an such success requires training

A BENSON OIL LAMP.

ix

Fig.11 From 'Domestic Lighting: The Work of W. A. S. Benson & Co. Limited', a four-page advertising supplement in *The British Home of To-Day: A Book of Domestic Architecture and the Applied Arts* edited by W. Shaw Sparrow, London, 1904.

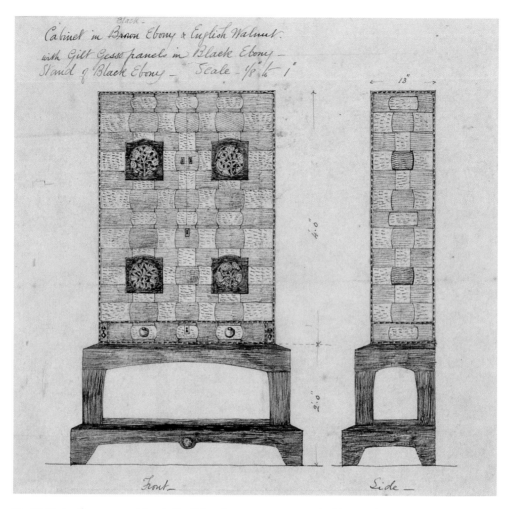

Fig.12 Design for a store cabinet in English walnut veneer on a stand of brown ebony by Ernest Gimson, dated 3 December 1901.

OPPOSITE

Fig.13 Cabinet in English walnut designed by Ernest Gimson in about 1907. From the catalogue of the exhibition of Gimson's work at Debenham and Freebody's, London, December 1907. The cabinet was for sale at £35 10s.

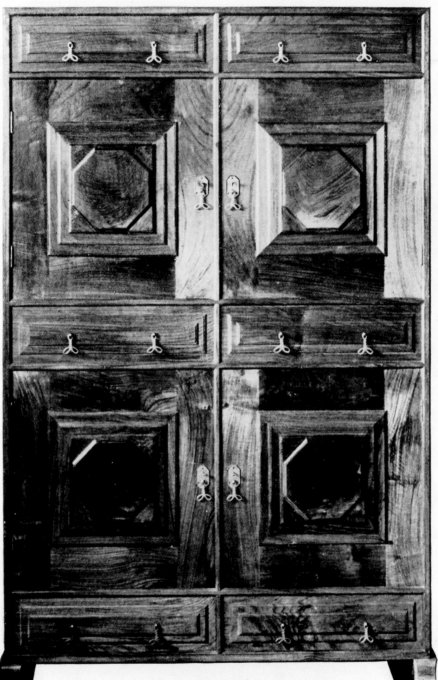

No. 1. Cabinet in English Walnut.

CHAPTER VIII. ON THE NEED FOR THE ESTAB-LISHMENT OF COUNTRY SCHOOLS OF ARTS AND CRAFTS.

NE of the ways of attaining once again to that higher standard of work and life in country crafts, to which I alluded in my last chapter, is the establishment of country schools of art and craft; & I would like in this chapter to show what should be their purpose and service for the community, and what they should mean for us in England in our present state of development. I postulate country, not town, conditions—that is to say, the conditions of any community where the population does not exceed from 4,000 to 5,000 souls—and the school I have in mind should be possible in villages where the population is not less than 500. Where there is energy & earnestness and a little intelligent enthusiasm on the part of resident landlord or parson it can be carried on in a humbler form with even smaller numbers.

Now, while I shall look at my school first from the point of *The Art in* view of the producer, and in more particular detail from that *Modern* of the builder and his allied crafts, its service must not be for *Eaucation is* the producer alone. The net must be spread for the whole *the Art of* village. The art we have by modern education to find is, as it *Life* always has been, the art of life; and to build well or to do anything else well, means first and foremost that we must well

i4

Fig.14 First page of 'On the Need for the Establishment of Country Schools of Arts and Crafts' by C. R. Ashbee, Essex House Press, London and Chipping Campden, 1906. This formed the final chapter of *A Book of Cottages and Little Houses* and was also reprinted as a pamphlet.

THE CRAFTS

If you are sufficiently interested in this subject to agree or disagree with us, we hope you will take an early opportunity of coming to see us. We have always a varied and increasing selection of beautiful things, both ancient and modern.

THE GREAT BARN,
LYGON COTTAGE.

RUSSELL & SONS

Furniture, Metalwork, China, Pottery, Glass, Fabrics and Domestic Objects

LYGON COTTAGE, BROADWAY
WORCESTERSHIRE

Fig.15 The final page of the pamphlet *Honesty and the Crafts* by Gordon Russell, 1923, with his drawing of the Great Barn, Lygon Cottage, the first site of Russell & Sons Broadway, Worcestershire.

AN EXHIBITION of COTSWOLD ART & CRAFTSMANSHIP

September 7th to 30th, 1935

OPEN DAILY, 10 a.m. to 5 p.m.
Wednesdays and Saturdays, 10 a.m. to 8 p.m.

ADMISSION FREE.

Transferred from Campden, Glos.

(By courtesy of the Campden Exhibition Committee)

To Cheltenham Art Gallery

D. W. HERDMAN, *Curator*

P.T.O.

Fig.16 The cover of the catalogue to an exhibition of Cotswold Art and Craftsmanship, 1935, with a woodcut of St James's church and almshouse, Chipping Campden by F. L. Griggs.

CHAPTER FOUR
THE DECLINE OF THE MOVEMENT
IN ENGLAND, 1910–19

Introduction

The second decade of the twentieth century was a difficult one for the Arts and
Crafts Movement. The very term 'Arts and Crafts' was recognized as a millstone
round the neck of the craft community. Benson wrote that the public was
'bewildered by the widespread adoption of the name Arts and Crafts by innumerable
minor societies and trades'. [1] Gimson avoided using it in his proposal for an
Association of Architecture, Building and Handicraft in 1917, substituting the term
'Handicraft Movement'.

The great success of German and Austrian designers, especially the Deutscher
Werkbund, forced British designers to reassess their work. The 1908 exhibition of
German Decorative Art at Munich was heralded as an example of what could be
done. Exhibitions of British work were held on the continent in Ghent (1913) and
Paris (1914) – the latter was cut short by the outbreak of the First World War.
Henry Wilson, President of the Arts and Crafts Exhibition Society, was determined
that the 1916 show should not only go ahead but also blaze a trail for post-war
reconstruction.

The formation of the Design and Industries Association (which became known
as the DIA) in 1915, involving leading Arts and Crafts figures such as Lethaby,
Heal, the silversmith Harold Stabler (1872–1945), the architect Cecil Brewer
(1871–1918), and Harry Peach (1874–1936) of Dryad Handicrafts, caused a rift
in the Movement. The DIA promoted straightforward standards of design for
everyday products: 'Art is not a special sauce applied to ordinary cooking; it is the
cooking itself if it is good.' [2] The members wanted to work in tandem with
manufacturers to make more of an impact on mass-produced wares. Other designers
and craftspeople like Gimson remained sceptical of the commitment and motives of
manufacturers. In his responses (see 4.3.1 and 4.3.2 below) to Lethaby's attempts to
win him over to the DIA, Gimson made clear that his personal concern was for his
workmen and their job satisfaction rather than the production of cheap well-
designed goods.

Many of the older designers and craftsmen were involved in war work: the
younger generation were involved in active service, and many died. The determination
of the survivors to create something positive out of the horrors of war was dashed
by inflation in the post-war years.

4.1 Ananda Coomaraswamy: On the Loss of Handicraft and the Destruction of Culture

4.1.1 From: 'Domestic Handicraft and Culture' by Ananda Coomaraswamy
Education, June 1910, from a copy in the Royal College of Art Archives, pp 369–71

Ananda Coomaraswamy (1877–1947) grew up in England, the son of a successful Hindu lawyer from Sri Lanka and an Englishwoman. He trained as a geologist and married the hand-weaver Ethel Partridge (1872–1952), [3] the sister of Fred Partridge (1877–1942), jeweller with the Guild of Handicraft. After directing a mineralogical survey in Ceylon, the couple returned to England in 1906 and settled in the village of Broad Campden, Gloucestershire in the medieval Norman Chapel restored for them by Ashbee. Coomaraswamy continued to lecture and write about the spiritual role of art and handicraft in Britain, the Indian sub-continent and the United States.

> Let me begin with definitions. Once upon a time all handicrafts were domestic. It would not be wrong to say that none now are so. [...]
>
> To define culture is perhaps a harder thing. Plato identified it with the capacity for immediate and instinctive discrimination between good and bad workmanship, of whatever sort ... We may expand this definition by including a certain quality of recollectedness or detachment, a capacity for stillness of mind and body (restlessness is essentially uncultured), and the power of penetrating mere externals in individual men or various races. [...]
>
> When we consider the restlessness which characterises modern life, we need go no further to enquire what that evil may be. To be satisfied with imitations — to be able to endure a gramophone after once hearing a living singer — to walk upon a carpet covered with bunches of roses tied in ribbons — to call "art paper" a paste of china clay used for reproducing photographic illustrations in cheap books — for women in their dress to deform their internal organs and their feet — for men to use by preference dingy tubular garments best adapted not to show the dirt of the atmosphere they are content to breathe — to place imitative dexterity in art above the power of great invention or nobility of motif — to assume superiority of soul on the mere ground of increased empirical knowledge — to accept always the report of the senses against the report of intuition — to seek always for novelty — these things are the opposite of culture, and some of them are caused by, or made possible by the destruction of the domestic crafts. Perhaps it would be truer to say that both things, our loss of culture, and the destruction of handicraft, result from some inner malady which we do not comprehend; but even if this be so, we cannot fail to recognize the close connexion between the actual phenomena. Restlessness is born of idleness. Thought is stimulated by rhythmic (but not unintelligent) labour. When the senses are, as it were, told off to carry on their own work, then the mind awakens to ideas. I do not think that women are wiser because they have abandoned the spinning wheel and the loom for the office and the factory.

I think they have lost reflectiveness. One does not forget that the childhood of Christ was spent in a carpenter's shop, nor that two at least of India's greatest poets and religious teachers — Kabir and Tiruvalluvar — were weavers. I cannot think of any instance where the destruction of a handicraft has promoted culture. We should consider whether men or things are the greatest possession of a nation. [...]

I have already alluded to one other phase of the relation between industrialism and culture. I mean the destruction of culture in other, particularly Asiatic countries, as the result of mechanical over-production in Europe. [...]

Perhaps the extraordinary meanness of the English or Dutch manufacturer who sponges on Indian or Javanese design, and reproduces mechanical and very inferior imitations of it cheaply for the European or for the local Asiatic market has not struck you! The process is often described as "successfully contesting the village weaver's market". I shall not be so foolish as to suggest the governing of European manufacture by ethical considerations, for there is better work to do at present than such a ploughing of the sand. I do, however, wish to point out that the solidarity of the humanity, especially under modern conditions of easy transport, is too real to permit of such causes failing to re-act for the worse upon European culture. [4]

4.2 C. R. Ashbee: On the Purpose and Future of the Arts and Crafts Movement

4.2.1 From a letter from C. R. Ashbee to Henry Wilson, 16 August 1915

Following the death of Crane in 1915, Henry Wilson (1864–1934) was elected President of the Arts and Crafts Exhibition Society. The Society had been through a very difficult period following the financial failure of the 1912 Arts and Crafts Exhibition. Wilson's efforts as exhibition designer for well-received shows in Ghent and Paris immediately before the outbreak of the First World War [5] helped to ensure his election over other candidates including Lethaby and W. Anning Bell (1863–1933).

One of Wilson's first actions as President was to write to members inviting their views on the future policy of the Arts and Crafts Exhibition Society. To Gimson he wrote a long letter reminiscing about their student days in Sedding's office, concluding: 'I should like you to tell us much about the effect of your work in the district if you can see it yet. Also what place such work, such an enterprise, has in the immediate future. I want to see the countryside alive again – thousands of Gimson's blossoming with sedate loveliness all around me.' [6]

The response from Ashbee was typically and painfully frank, highlighting many of the issues which faced the Society and the movement as a whole. It is preserved in the Wilson Collection at the RCA.

Whether you are able to do anything in your new position depends on your power of getting a body of very individualistic, self-centred & 'diffident' men & women to combine.

Our traditions, training & methods for the last 20 years have all been <u>against</u> concerted action of any sort. The combination which we might have achieved, and which Crane missed his chance of bringing about, is I fear now too late. We have all of us been running our own little workshops and sideshows in our own way, without believing in the good intentions, or the ideas, or the 'bona fides' of 'the other fellow'. And though we may, in our hearts, sometimes have admired his 'work' as an artist, we have never realized something else was needed requiring in ourselves a greater faith, — for the sake of the 'Arts & Crafts' as a whole. In so doing we have, I fear, destroyed, for the sake of a petty individualism, the life and principles of a society.

Many of us have always regarded you, no doubt unjustly, as the arch-Individualist, the man who would never work with anyone and with whom no one could work. Now that we have made you Master of the Society — on the principle perhaps of making a gamekeeper of the poacher — you will be able to stand before us in a white sheet, or prove to us, by uniting us in an intelligent and far-seeing constructive policy that we were wrong. [...]

Our difficulty is not one of aesthetics, it is one of organization, of livelyhood (sic), of adjusting the conditions under which the Arts & Crafts can be practised to the mechanical environment of our time; in that sense our difficulty is social, human, ethical.

4.3 The Craft and Machinery Debate

Lethaby was one of a number of senior Arts and Crafts figures, including Benson and Image, who allied themselves with the DIA and the idea that a machine-made object could be as well-made, well-designed and useful as a hand-made one. He tried to persuade Gimson, one of his oldest and most respected friends, to join the Association. The letters below (4.3.1 and 4.3.2) outline some of Gimson's response to his arguments. Gimson's main concern was for his workshops. He did not argue against machine production per se but was firmly convinced that it was not for him or his workforce.

4.3.1 From a letter from Ernest Gimson to W. R. Lethaby, 18 April 1916 [7]

The question seems to be (to go straight at it) <u>who are interested in the crafts?</u> And I should like to find out just where the difference between us comes in — why you think I might do some good by designing bookcases for machines while I don't. I suppose all designers with workshops of their own have in unprosperous times been faced with the problem of machinery. It has faced me often — sometimes it seems to be a question of machinery or no shop at all and I have wavered about it but always ended by knowing that of the two alternatives I would rather have no shops at all.

And I wish you thought this right — from the craftsman's point of view. If one's interest in the work were only that of design and utility it would be different but it is in the men themselves too and their ways of work and through that to most other things in life as you know.

But with you I would like better coins and stamps and more intelligence in the planning of our towns and I get more pleasure from a good engine (for its living work) than from most museums and much more than from the usual Arts & Crafts show (for don't the crafts want purging and 'sensing' as they say here, as much as machine things?) Indeed I would give our great manly works of engineering their right place in our cities as things often of real beauty and some art. In fact we must all recognize that there is and will be a big field for engines and machines as long as people want their work and are happy in making and mending them. But your 98%! Isn't that too much? Should we not all recognize too that there is another field for craftsmanship as well? And aren't most of the things we really care about in this field — the sort of buildings we like — all the crafts you have written about and helped us to follow, and aren't the best workmen there too? If by pegging away here we could bring down that 98% I believe it would be about the best thing we could do, not for art only — that is a secondary matter, but for the national character and the whole labour and social problem.

But one of the aims of the D&I is to mechanise and commercialise this field although I believe it is the chief origin of their own desire for a cleaner and more intelligent life. For without the Crafts movement would they have grown to this need for a better and livelier look of things or have come by their judgement of good and bad design? Wouldn't they be wiser to keep their organization for those kinds of work in which they — as craftsmen — can never gain a footing, lest they end by choking the very source of their own aims.

4.3.2 From a letter from Ernest Gimson to W. R. Lethaby, 10 May 1916

My dear Lethaby, While writing now I will try and put out of my mind the first shock of the DIA pamphlet and the attitude of mind of the members I've talked with and to look at it all from your own standpoint. But first it's quite clear to me that machine made art has no difficulties for them and the life it points to no terrors: that they would run roughshod over the hand industries as failures and hopelessly out of date, that their thoughts are almost wholly on Design and Industry and the workers forgotten, and that they are doing their best to capture the Crafts schools and the young people for this point of view.

This seems to me to come from utterly false ideals of work and even if looked at simply as design and industry, to be a short-sighted policy: it is not you I know.

I am tempted to go through your letter and table its points as they come: I am with you entirely in wanting intelligence and character in all man's work and I want it about as much as I want anything and I want the work to be such as can take it. I want it in organizers and designers but a thousand times more do I want it in the people, and it is for that reason that I so much dread the swamping of hand industry by machinery and of its ideals by competitive trade.

In organising from this point of view I believe intelligence would show itself in gradually withdrawing mechanical processes from great tracts of work that are now overrun by them.

We want great open spaces in our industrial life as in our industrial towns, or we shall go under.

Even in printing there ought to be a little open space kept for writing as there is now, and all for its good. But in printing intelligence shows in the words rather than in the lettering and the analogy with other crafts becomes confused. It has of course spread intelligence and I would have it as well done as we can get it and so with money and telegraph poles and other things. As for cities I can see no opposition in ideals between right city life and right village life. Each is what the inhabitants make it and they should both be made inspirations.

My Australian Capital design [8] *(where you seem to see an inconsistency) came from the desire to test one's ideals and to see what they would look like as applied to town planning and town building. Just that and only that. I wanted the results to confirm the unthinking man not altogether out of place in present day city problems. I would plan towns and factories. I* want *to plan them and* build *them too. I would design railway stations and rebuild the furniture shops in Tottenham Court Road. I want to do it and in my own way so that there need be no conflict with my other work. But as to setting up machine furniture shops I feel differently. It would be for one thing outside my interests and temperament and I should really have to begin by forgetting early aims that have been helpful. For the intelligence and character of furniture makers I want to see more of their work done by their hands and there is no intelligent reason for it not to be. It is only trade habits and mistaken views that stand in the way. And these reasons would also apply to designing for other people's machines — I couldn't enjoy it and moreover I couldn't do it either for I know nothing of the 'inherent possibilities' of woodwork machines (I wonder whether Wilberforce recognized the inherent possibilities of slaves). As to the type of machine design that you suggest — thin, hard, precise, that is the kind to make for certainty, but what sort of intelligence would be in its expression? Wouldn't it be something to chill us to the very marrow of our bones? And so with no end of other work it seems to me that machinery can only dehumanise it and that there it is accurst and the surest way to go under is to employ it! But I can't call all machinery accurst or anything like at all, only where it is unintelligently applied — railways, we will say, up Snowden, or turners taken from their lathes to poke sticks into holes in machines.*

Nobody could enjoy designing turning for machines. If only we could look straight at the man how quickly the fog that hangs about problems of art, labour, commerce and education would begin to clear away, wouldn't it? I believe its effect would soon be seen in the National Debt. And if we could keep our steady eyes on our Edens and Utopias and Kingdoms of Heaven might there not be some commercial advantage in that too? After all it seems to have been our Craft Eden that made possible the German Werkbund and I suppose too the English Design and Industries and I believe it might point the way to something infinitely better worth having than either if we could keep our shoulders to the wheel a little longer and have a few chances given us of showing the application of our aims to things of larger consequence — town planning — town building. It is to me a most unintelligent thing that there isn't a Lethaby City in our Empire to show us how to use the best

result of our discoveries and at the same time to find for us some of the good things that have been lost. In our progress, while we have gained so much with one hand we have, (not by necessity but by sheer inattention) dropped too much with the other. I should like to pay some of my tax to the age by helping to pick some of it up again! I never feel myself apart from our own times by harking back to the past — to be complete we must live in all the tenses — past, future as well as present.

4.3.3 From: 'Art & Commonsense', a review of *A Modern Creed of Work* [9]
by A. Clutton Brock, in *Country Life* 9 September 1916, p.4

> *No one to-day can write a more persuasive tract than Mr. Clutton Brock, and he is at his best in this weapon he has given to the Design and Industries Association. He probes into the reason for the ugliness in common things, ugliness thrown into more marked relief by the laborious addition of meaningless ornament. He pleads for a religion of workmanship and for a religion of design, if either are to be bettered. Manufacturers and shopkeepers have a crazy belief that the public does not want good design or good workmanship, but prefers cheap and pretentious ugliness. The Germans, who know about these things to our loss and discredit, believe nothing of the kind. They employ the serious artist to design things, however simple and machine made by the million. But we have far greater artistic talent than the Germans, and only need something akin to their energy and organization to bring this wasted capacity into bearing. Mr. Clutton Brock puts the case with remarkable clarity: "The cause of the Design and Industries Association means more than a little pleasure for cultured people. It means what we call the social question. It means ultimately a change in the relations between producer and consumer; it means, in fact, the future of civilisation. For you cannot have civilisation where the lives of millions are sacrificed to produce rubbish for thousands who do not enjoy it when it is produced." But this tract must be read, and that done, the reader will make haste to join the Association, which has its home at 6, Queen Square, W.C. It works modestly and has now only published a pamphlet which is called "The Beginnings of a Journal". But the report it furnishes of serious work done and exhibitions held and the notes on the D.I.A. creed are witnesses to the use and vigour of the Association. Of the scores of societies and leagues which are hoping to make this a better and saner country to live in, the Design and Industries and the allied association, the Civic Arts, are two of the hopefullest. For both deal with art as a branch of common-sense, and not as a muddled mystery of aesthetic theory.*

4.4 The 1916 Arts and Crafts Exhibition

The 1916 Arts and Crafts Exhibition, the eleventh staged since the Society's foundation in 1888, achieved something of a coup. It was held for the first time

in Burlington House, the home of the Royal Academy whose elitism had inspired the initial formation of the Art Workers' Guild.

The exhibition was planned as an attempt 'to show how the genius of English artists could be applied to the decoration of towns, cities and villages'. [10] It culminated in the Hall of Heroes. The gallery normally reserved for Academy banquets was transformed by Wilson into 'monumental and elaborate Byzantine Hall'. [11]

4.4.1 From the Introduction by Henry Wilson to the Catalogue of the Eleventh Exhibition, pp 17–20

"Thank God there are people in England who care for these things. After the war it will be too late!"

He was back from the front, and in our Hall of Heroes I was explaining the intention of the Exhibition.

At the sudden passion in his voice our eyes met and the look, heard of, but hardly believed in, gave me, through one of those rare timeless moments of intensified consciousness, the knowledge that all the pity and the pain, all the strangling waves of horror that beat upon the beach of death, had but stripped the matrix, that hid the burning home, revealing the eternal soul within.

I saw besides, the fields of ravished Flanders and desolated France, ruined Poland, Rheims wrecked and Venice bombed; the ghastly tangle of the trenches; then leagues on leagues of basted soil bedewed with the blood of young humanity, a humanity leaping with song and laughter on destruction, and I knew that all the labour of all our lives for all their term could not reward such sacrifice or make fit expiation for the wrong that called it forth.

Now that the Western world is one vast wound, which the forces of destruction are daily enlarging, the least sign of reconstruction comes like a benediction to those who have been in the conflict. "Thank God there are people in England who care for these things. After the war it will be too late; it must be done now." The words came as a complete vindication of our enterprise and a blessing to our labours. Let doubters take courage. [...]

We invite the official world, the world of education, the world of trade, merchants, manufacturers, the heads of universities, colleges, schools and technical institutes to flock to Burlington House not merely for pleasure as always, but for pleasure and profit and patriotism.

To give encouragement to our craftsmen is now the first necessity. Do this, and the whole life of the Nation gains. Neglect it, and we shall fail utterly in the great task of reconstruction which the coming of peace will bring to us ...

There is a British quality in work. Subtle, elusive, undefinable, but easily recognizable everywhere. Let us cultivate that. It suits our soil. That is true enterprise, true wisdom, true patriotism. [12]

4.4.2 From 'The Arts and Crafts at the Royal Academy' in *The Nation*, Vol.103, November 1916, p.524

> *The Miracle has been worked and the Arts and Crafts Society, of old considered the most un-Academic society in England, is established in Burlington House for at least a couple of months. Sir Edward Poynter,* [13] *who formally opened the exhibition, seemed himself appalled by the signs of revolution on all sides of him in his own once sacred precincts, and, in his speech, was careful to point out and emphasize the fact that the Academy can claim credit for nothing save the loan of the galleries.*

4.4.3 DIA Statement of Purpose in the Catalogue of the 1916 Arts and Crafts Exhibition, p.105

> *Room 10: exhibit 193*
> *Design and Industries Association exhibit*
> *The aim of the Design and Industries Association is to improve the quality and fitness of goods on sale to the general public through the usual channels. The articles in this section are not on sale in the Exhibition.*
> *The maker's name is affixed to each, and these goods should be asked for under the maker's names at the ordinary shops.* [14]

4.4.4 From The *Star*, 'British Arts. Interesting Exhibition at Burlington House', 6 October 1916

> *There has been in the last twenty years a remarkable revival of English handicrafts, but the unpleasant fact is that Germany stole our ideas and exploited them. The German Government sent representatives to our art schools, and those representatives went back to their art schools with our designs and our methods; their manufacturers saw the commercial possibilities of the triple alliance of art and science and industry, and they set about capturing the world market in decoration, and furniture, and books, pottery, and metal work. The war has interrupted their attempt, and given our own manufacturers the chance to awaken to the fact that art in industry pays.*

4.5 On the Future of the Crafts in the Cotswolds

4.5.1 From 'The Association of Architecture, Building and Handicraft' a paper by Ernest Gimson, 10 June 1916

Gimson had been developing plans for a craft community in the Cotswolds for some

years. In 1910 he wrote to his brother, Sydney, 'I am negotiating for a few acres of land near here & should like to talk with you some day about the business part of it'. [15] The disruption to the workshops caused by the outbreak of war and the feeling that something positive must result from the cataclysmic events spurred him on to develop his proposal for a radical craft community based on architecture and the building crafts.

The proposed crafts were wide-ranging and not limited to those already practised by Gimson and his associates at Sapperton. They included silverwork, goldsmithing and jewellery under the direction of John Paul Cooper and Henry Wilson; needlework with May Morris and Mary Newill; and spinning, weaving and dyeing with Ethel Mairet. In addition George Jack was to be approached concerning carving and mosaics; Augustus John (1878–1961) for wall painting, Eric Gill for sculpture and inscriptions and the agriculturalist Harold Ellis for his experience in farming.

It is proposed to form a Working Association of Architects, Builders and Craftsmen with a view to the organisation and development of the Handicraft Movement by carrying into effect the following proposals:-

Proposal 1.
To strengthen the influence of the Handicraft Movement in the building of our Towns and Villages by the inclusion of Architecture and Building among the chief work of the Association.

With such a membership as is proposed the Association would be in a position to design and carry out important schemes of Town-planning, Architecture, Building and Decoration. Feeling deeply that the Handicraft Movement can never express its whole meaning or grow to its full strength until it can show more clearly its bearing on Architectural Design and Building, it would be the Association's aim to develop this part of its work to the utmost of its power. To show the capacity of its members for undertaking complete constructive schemes in co-operation, it is proposed that they should prepare Architectural Models to be exhibited in London and to be kept afterwards in the Association's Galleries.

Proposal 2.
To further the present work of the members in their personal handicrafts by working in association and in close connection with Architecture and Building.

The constant association of the different crafts and their co-operation in architectural schemes should stimulate and strengthen them in design and help to bring the whole work of the Movement into unity of aim and expression. The personal crafts would also reap the economic advantage of sharing their expenses in show-rooms, exhibitions and publications.

Proposal 3.
To organize the Handicrafts to take a larger part in industrial life by establishing

additional workshops for making in quantity things of common use at prices within the reach of average incomes and to build a Village for 200 handworkers for this purpose.

With the high reputation English Craftsmanship has now won in our own and other countries it is believed there would be very large sale for well made and well designed things of common use at moderate prices. It has been something of a reproach to the movement that it has been too much concerned with producing elaborate and costly work and that it has done too little in making simple things that most people use and can afford to buy. But making simple inexpensive things means a business organisation for production in quantity and most craftsmen have been too closely occupied in their own personal handicrafts to have been able, or to have desired, to establish such businesses. Also, as it has been one of the good influences of the movement to lead craftsmen to take their work into the Country, those that have wished to develop their crafts into industries have mostly been met with the difficulties of lack of cottages and good schools for the workers and their children and of the buildings needed for their social life. With the necessary buildings and a business organisation of the crafts the chief obstacles that have kept the movement from growing in this direction would be removed.

The Village would be built by the Architects and Builders of the Association and the building of it would be a great help to the success of the scheme, not only as showing the vital difference between such work and the usual professional Architecture and Commercial Building, but also in training a band of masons, carpenters and others in right methods for future employment in the Association workshops.

For the complete organisation of the village life, it is proposed to acquire enough land for the agricultural support of the village and to manage it primarily for this purpose under the supervision of a skilled agriculturalist, who would be a member of the Association. There is an estate in the Cotswolds, near the present workshops of the proposed directors of many of the crafts, that it is thought could be acquired and that would be an eminently suitable site for the workshops and the village. It would not be necessary for all the workshops to be in the village, nor in all cases, need the directors with workshops in the village live there themselves as long as they could exercise proper control from outside and leave a responsible manager in charge.

Proposal 4.

To establish centres in other parts of the Country that would work in affiliation and thus help towards the growth of our Architecture and Handicraft into a national tradition.

It is thought that when the Association became complete centres might be formed near London, Birmingham and Edinburgh. When enough centres were in working order it would be the intention to open joint showrooms in London, co-operate in exhibitions, and, looking further ahead, to share in the support of representatives in other Countries.

Proposal 5.

Encouraging all skilled handicraft.

Great importance would be given to this proposal as it would be a necessity of the workshops

that there should be a sound system of training to fit the young to take their places in the work of the Association and carry on its traditions. There would be a workshop in connection with the Village School, where the children would learn the beginnings of some of the crafts and a Craft School for apprentices and pupils. Pupils in Architecture would have an invaluable training in a course of practical work in the Builders' Yard. It would be the intention that the Craft School should grow beyond the needs of the Association's workshops and become a centre for training craftsmen from all parts of the country. With the teaching that would be given by experienced masters and the training that would be given in the workshops in the actual practice of the crafts, the school should become a helpful influence in the growth of the movement.

As regards the training of apprentices, it is worthy of note that one of the reasons given by employers for failing to continue the system of apprenticeship is that the excessive rents in large towns make it impossible for them to devote bench space to any but skilled workmen whose output gives full return for the space they occupy. This economic argument has weighed with the Association in deciding to establish its centre of activity in the country rather than in a town.

It is believed that there is a great future for the Handicraft movement and that such an Association as is proposed, would be the first sure step from the position it has now reached to one of vital influence on Architecture, Building and Industry. It is now recognised that English handicrafts stand firm. They have overcome their first difficulties and separately established themselves. It now remains for them to come together and organise the movement to win a larger field for its work and influence.

The Membership of the Association.

To insure the success of the undertaking, only experienced Craftsmen who are already known as among the leaders in their crafts, would be included in the membership. The Architects and Builders in the Association would also be craftsmen and they would act as Directors of workshops. [. . .]

Finance.

It is estimated that the capital required for carrying out the complete scheme for a Village for 200 workers would be £116,000, divided as follows:-

Cost of the Village, including 100 workmen's cottages, 6 bigger cottages, 4 houses, village hall, village shop, inn, hostel for 50 workers, craft school, roads, water supply, etc.	£49,000
Business capital for financing the new workshops, including cost of building workshops and showrooms.	£40,000
Taking over members' present workshops.	£7,000
Land	£16,000
Initial expenses of advertising, etc. etc.	£3,000

It is proposed to raise £37,000 of this sum by debentures @ 5%.

The capital of the Company would be £78,000 divided into 39,000 6% cumulative preference shares of £1 and 39,000 ordinary shares of £1.

It is proposed to begin with a one-third scheme of workshops and village buildings and with the full amount of land, entailing a cost of £60,000 spread over 2½ years.

It is anticipated that the Bank would take up the debentures, that 10,000 of the ordinary shares would be taken by the members in cash and that the members would receive payment for their present workshops in preference shares.

It is suggested that the crafts of spinning, plain weaving, basket-making, plain cottage chairmaking and certain kinds of pottery and needlework should be carried on as home industries for the benefit of the Association and the Villagers.

It is proposed that the directors of the workshops should receive a small salary and a percentage of the profits on the work under their direction.

In the case of personal handicrafts, it is proposed that the Association pay the members the value of their sales, less 10%.

Advertising.

Catalogues to be published of all repetition work designed to be made in quantity.

A pamphlet to be published giving a list and a short description of the different kinds of work the Association would undertake.

A book to be published with illustrations and descriptions of members' past work.

A series of essays to be published explanatory of the Association's views.

A series of fully decorated architectural models to be prepared to show the Association's capacity in undertaking important co-operative schemes in Architecture, Building and Decoration.

The Association to show to an agreed scheme at each Arts & Crafts Exhibition.

Each year that there is no Arts & Crafts Exhibition the Association to hold a London show of its own.

Showrooms to be built in the Village in the form of a house with each room fully furnished by the Association.

The Association to have a representative in London with offices where enquiries could be answered and where catalogues, illustrations and some samples of work could be seen.

The Village itself would be an invaluable advertisement of the Association's work in many kinds of buildings and building crafts and should attract much interest in the Association's work generally. [16]

4.5.2 From a letter from Peter Waals to Albert Herbert ARIBA, 2 December 1919

Gimson's workshops had reopened at the end of the war, although there were issues concerning rates of pay. Some of the returning craftsmen, who had been earning the same or more doing less skilled war work, were not prepared to return to Daneway

on pre-war wages. However, his plans for a new crafts community were cut short by illness and his subsequent death in August 1919. Sidney Barnsley took over day-to-day running of the workshop until the work in hand was completed. Towards the end of the year Gimson's foreman, Peter Waals (1870–1937) obtained the Gimson family's agreement to enable him to set up his own workshop in the village of Chalford near Stroud. He was able to buy the remaining stocks of timber and tools and acquired the goodwill of the business, although Gimson's designs and working drawings remained with his widow. Many of the craftsmen who had worked with Gimson went on to work with Waals through some very difficult years in the 1920s and 30s.

> *Dear Sir*
>
> *I have been closely associated with the late Mr. Ernest W. Gimson since the inception of the business and beg to give notice that I have acquired the plant and valuable stock of seasoned timber from the executors & propose to carry on the business in all its branches.*
>
> *The work produced at the Daneway Workshops has attained a world-wide celebrity for quality of design & execution and it will be my aim to maintain the high standard the clients of the late Mr. Gimson have learnt to expect. I have been fortunate in retaining the services of all the craftsmen previously employed by Mr. Gimson and am thus in a most favourable position to continue the production of furniture of the highest class.*
>
> *At the same time, by careful organisation & the judicious use of machinery, I hope to be able to produce distinctive furniture for a proportionately lower price than that required for exclusively hand worked productions. In addition to furniture the Daneway Workshops have produced – and are in a position to continue to produce – high class joinery of all kinds and in particular Church work in English oak.*
>
> *I hope that the clients of the late Mr. Gimson – and all who are interested in the best traditions of craftsmanship will give me the opportunity of submitting designs and estimates for any high class work which they may require.* [17]

Notes

1 Manuscript dated 20 January 1918, AAD 1/22-1980.
2 Lethaby quoted by MacCarthy, F., *All Things Bright and Beautiful: Design in Britain 1830 to Today*, George Allen & Unwin, London 1972, p.80.
3 In the summer of 1910, the Coomaraswamys went on a tour of India collecting work for an art exhibition to be held in Allahabad. Ethel returned alone because Ananda had fallen in love with someone else. She subsequently married Philippe Mairet and as Ethel Mairet became a leading figure in the twentieth-century craft revival.
4 This piece was a transcript of a talk given to the Association of Teachers of Domestic Science at their annual conference held in the University of London, 28 May 1910.
5 The exhibition at the Louvre in Paris was due to run from April to October 1914. The outbreak of war in August meant that the exhibits had to be stored in the vaults of the museum for the duration of the war.

6 Henry Wilson to Ernest Gimson, 12 October 1915, Wilson collection, RCA.

7 From transcripts in the Burrough archives, CAGM.

8 In 1912 Gimson was one of a very small number of British architects to enter the international competition sponsored by the Australian government for the new state capital at Canberra (the conditions set for the judging did not meet the approval of the RIBA).

9 This was a pamphlet published by the DIA price 3d.

10 Quoted by Rose, P. '"It Must Be Done Now": The Arts and Crafts Exhibition at Burlington House, 1916' in *Decorative Art Society Journal* 17, p.4.

11 Ibid p.10.

12 AAD 1/117-1980.

13 Sir Edward Poynter was President of the Royal Academy in 1916.

14 AAD 1/117-1980. This short statement of purpose was the only one made by the DIA in the catalogue. However, many of the reviewers picked up on this new element in the exhibition.

15 Letter to Sydney Gimson dated 25 June 1910, CAGM.

16 'The Association of Architecture, Building and Handicraft' a paper by Ernest Gimson, 10 June 1916 in the Wilson collection, RCA.

17 Part of a collection in the Arts and Crafts archives, CAGM.

CHAPTER FIVE
THE LEGACY OF THE ARTS AND CRAFTS
MOVEMENT, 1920 AND AFTER

Introduction

The Arts and Crafts Movement was sidelined as a major force in British design by 1920. As architects and design reformers, like the architectural historian, John Gloag (1896–1981), ranged themselves round the DIA and the Modern Movement, so the Arts and Crafts lost that strong sense of social reform and vision which had proved such a unifying and invigorating force in its early years.

The influence of the Movement on art education remained strong through the first half of the twentieth century. Many craftsmen and women combined craftwork and running a workshop with teaching. At Loughborough Training College, for example, Peter Waals and Sidney Barnsley's son, Edward Barnsley introduced the Cotswold furniture tradition to new generations in the 1930s and 40s and it remains an influential inspiration for designers and makers today.

Pockets of craftsmanship still survived outside the metropolitan mainstream. Craftsmen and women such as the furniture makers, Romney Green and Eric Sharpe (1888–1966), and the weaver Ethel Mairet focused in on their chosen craft. Bernard Leach (1887–1979), working with the Japanese potter Hamada Shoji (1894–1978) in St Ives, Cornwall, laid the foundations for the new Studio Pottery movement. In many ways the Arts and Crafts metamorphosed into the Craft movement.

5.1 Roger Fry: On Art in Modern Society

5.1.1 From 'Art and Socialism' in *Vision and Design*, by Roger Fry, Penguin Books, London 1920, 1937 reprint pp 60, 61–2

Roger Fry (1866–1934), painter and art critic, was also one of the leading figures behind the Omega Workshops. The Workshops were set up in 1913 producing furniture, textiles, mosaic, stained glass and pottery designed by artists such as

Fry, Duncan Grant and Vanessa Bell. They exhibited at the 1916 Arts and Crafts Exhibition and survived as a group until 1921. Fry was influenced both by the ideas of Morris and the Arts and Crafts Movement and contemporary art, particularly Cubism and Fauvism. This essay was reprinted with considerable alterations from an article in *Harpers* 1912.

> There is in truth, as Ruskin pointed out in his "Political Economy of Art", a gross and wanton waste under the present system. [...]
>
> But if we suppose a state in which all the ordinary objects of daily life – our chairs and tables, our carpets and pottery – expressed something of this reasonableness instead of a crazy and vapid fantasy the artist as a pure creator might become, not indeed of less importance – rather more – but a less acute necessity to our general living than he is to-day. Something of the sanity and the purposefulness of his attitude might conceivably become infused into the work of the ordinary craftsman, something, too, of his creative energy and delight in work. [...]
>
> We are so far obliged to protect ourselves from the implications of modern life that without a special effort it is hard to conceive the enormous quantity of "art" that is annually produced and consumed. For the special purpose of realising it I take the pains to write the succeeding paragraphs in a railway refreshment-room, where I am actually looking at those terribly familiar but fortunately fleeting images which such places afford. And one must remember that public places of this kind merely reflect the average citizen's soul, as expressed in his home.
>
> The space my eye travels over is a small one, but I am appalled at the amount of "art" that it harbours. The window towards which I look is filled in its lower part by stained glass; within a highly elaborate border, designed by some one who knew the conventions of thirteenth-century glass, is a pattern of yellow and purple vine leaves with bunches of grapes, and flitting about among these many small birds. In front is a lace curtain with patterns taken from at least four centuries and as many countries. On the walls, up to a height of four feet, is a covering of lincrusta walton [1] stamped with a complicated pattern in two colours, with sham silver medallions.... Above this is a wall-paper in which an effect of eighteenth-century satin brocade is imitated by shaded staining of the paper. Each of the little refreshment-tables has two cloths, one arranged symmetrically with the table, the other a highly ornate printed cotton arranged "artistically" in a diagonal position. In the centre of the table is a large pot in which every beautiful quality in the material has been carefully obliterated by methods each of which implies profound scientific knowledge and great inventive talent. Within each pot is a plant with large dark green leaves, apparently made of india-rubber. This painful catalogue makes up only a small part of the inventory of the "art" of the restaurant.... Display is indeed the end and explanation of it all. Not one of these things has been made because the maker enjoyed the making; not one has been bought because its contemplation would give any one any pleasure, but solely because each of these things is accepted as a symbol of a particular social status.

5.2 On Modern Design

5.2.1 From *Furniture for Small Houses* by Percy A. Wells, B. T. Batsford, London 1920, pp 1–2

Percy Wells (fl. 1909–34) was head of Cabinet Making at the LCC Shoreditch Technical Institute. Under his supervision, students made a complete set of the furniture designs illustrated in this book, completely furnishing a five-roomed cottage, including a living room, parlour and three bedrooms. The furniture was lent to the Design and Industries Association for exhibition purposes. He wrote a number of practical books on furniture design and making.

> *The designs have been prepared in response to hundreds of applications — many from overseas — for assistance in producing pleasant and inexpensive furniture. [...]*
>
> *It is not claimed that the attempt exhausts the possibilities of design, construction, or finish in suitable furniture for small houses. There is a wide field for local craftsmanship and tradition to vary both form and the manner of making. The designs here shown are done more for experiment and suggestion. Some new ideas have been introduced in the making and finishing. There is no article which cannot be produced by modern methods, hand or machine. Ease in moving and cleaning, and a minimum of work in dusting — pressing needs of the housewife — have been duly considered. Non-essentials, such as cornices and pediments, have been discarded, and the whole aim of the designer has been to suggest a type of furniture which is useful, pleasant to look at, and moderate in price. It is readily admitted that the great bulk of cheap furniture has been both flimsy and ugly. Little or no thought has been given to suitable proportions and dimensions for small rooms. The designers and manufacturers must not take all the blame for this, for the public have been too ready to demand a showy article with plenty of polish and plate glass rather than a really serviceable one. This is well illustrated by the type of sideboard or overmantel overloaded with ugly and useless details which add to the cost and mean so much labour to keep clean. On the other hand, if the public are to be educated in selection and taste, education can only come through the designers and makers who put the goods on the market, and the salesman who comes into personal contact with the purchaser. There is now a decided demand for brighter homes and better furniture, and there is no excuse that ugliness and flimsy work should be the commonly accepted features of cheap goods. Fitness for use, good proportions, and bright, pleasant colour will not cost any more than bad proportions and unpleasant colour ... Machine productions should make no difference to the right application of the above principles, and we have to get rid of the fallacy that machine-made articles must necessarily be unpleasant in form and repulsive to good taste. It is hoped that the general public will begin to realise some of these simple and practical principles, and to apply them when purchasing household goods. With a public asking for better things and knowing what they wanted there would be no doubt as to improvement in quality.*

5.2.2 From *Honesty and the Crafts: A Plea for a Broader Outlook* by Gordon Russell,
published privately, 1923, pp 5–10

Gordon Russell (1892–1980) grew up in Broadway, Worcestershire and the
Cotswold town and its craft traditions remained the heart of all his work. He
wrote and illustrated this pamphlet (see Fig.15) setting out his support for modern
design just as he was becoming recognised as a furniture designer. It was the first of
many books, articles and broadcasts in a distinguished career as a designer, business
man and administrator. He was appointed Director of the Council of Industrial
Design in 1947.

> *"Wonderful, isn't it? Only an expert would ever guess it wasn't old!" How often has one heard
> this remark made in a tone which leaves no doubt that the speaker considers it a vast achievement,
> like the drawing which is "just as good as a photograph." But how many people who make similar
> exclamations ever pause to consider what they mean? [...] Are we to admire things because they
> are beautiful, or because they are old? [...]*
>
> *Can any reasonable person suppose that such forms of dishonesty are not reflected in the morals
> of people at large? One has only to notice the appalling increase of petty crimes to discover that some
> influence has been at work which has fogged the line of demarcation between right and wrong.*
>
> *And how can we help to alter this state of things?*
>
> *Well, firstly by educating ourselves to appreciate good work of every kind. We use the term
> "work" in its widest sense; it embraces needles, brushes and dust-bins equally as much as buildings,
> furniture, jewellery and motor-cars. By seeing that everything we have or use is eminently suitable
> for the purpose for which we have or use it, and by forgetting to be "artistic" and being natural
> instead.*
>
> *It is stupid to buy things one does not like because one's friends say they are the "right" things
> to buy. Something is wrong with a home that one does not feel at home in, and it is better to have
> a real love for even a piece of Victorian mahogany than to repeat hackneyed phrases about Jacobean
> oak. [...]*
>
> *In short, we must abolish shams and return to a study of fundamentals. So we shall once
> again bring honesty into everyday life and beauty will surely follow, for the highest form of art,
> reduced to its simplest elements, is merely the doing of any one thing as well as it can be done.*

5.2.3 From 'Hand-painted pottery', a letter from C. F. A. Voysey to the Journal of the
Royal Institute of British Architects, 22 December 1923, Vol.3, p.115

> *The exhibition of Mr. and Mrs Alfred Powell's* [2] *china at Brook Street Gallery is more interesting
> than many of the previous ones we have enjoyed. And mainly so, because of the improvement
> in lustre and in the quality of design, which has, besides its sensuous qualities, an interest both*

intellectual and emotional. The five heraldic plates are remarkable in every quality and interest. Designed to go against a white wall, we feel sure the effect of colour will be refined and rich.

The little octagonal dish with eagle is so beautifully drawn and balanced that any of the Early Japanese artists might have been proud to do it.

Above this plate is a clever and original design for a circular dish with pool and fishes and a border on the rim of buildings reflected in the water, quite amusing and pretty in effect.

The 'variety set' tea service is so gay and reminiscent of nature's joyousness, one wishes all one's plates and dishes might be sprinkled with sprigs of flowers.

Mr. and Mrs Powell are such delightful artists that one wonders why the manufacturers do not provide them with better shapes for their pottery. Some of the old shapes revived in jugs and bowls are as good as they can be. But we saw no cups or teapots that gave any pleasure by their shapes.

The texture and the glaze still bear the impress of mechanical perfection which make us long for more of the Chinese quality. The pitted 'blobby' surface that when glazed plays with light as if it enjoyed the game. Why are we so sadly smooth and mirthless?

5.2.4 From *Instead of a Catalogue* by A. Romney Green, published privately by the New Handworkers' Gallery, 1928 pp 19–20

People often suppose that it is against the principles of the modern movement in applied art to use power-driven machines, and that the customer pays for this obstinacy in high prices. But the 'craftsman's' prejudice against new inventions has never been formally sanctioned by any exponent of our principles from Morris onwards: and I can safely repudiate it on my own account. I was the first boat sailor to adopt in practice eight years ago a new rig ... which has been justified by the latest scientific experiments: I am probably the first woodworker to use co-ordinate geometry in furniture design: and I have invented a new method of boat-designing from solid equations. The objection to new inventions is that they are usually capable of abuse, and are invariably abused if possible. But the 'craftsman's' social ideal is usually that of a rural England in which agriculture, art and industry flourish side by side in that order of recognised importance, but thoroughly equipped with windmills, watermills, and electric power. Heavy sawing, or the thicknessing of badly sawn wood should certainly under modern conditions be done by machinery: and if I were not easily able to put such work out I should doubtless instal (sic) the necessary machinery in my own shop. But the cheapness of cheap modern furniture is mainly due either to the sweating of small workshops or to a mass-production so commercially-minded that it leaves its unmistakeable mark in the vulgarity of the product. First class work must always be expensive if the worker's standard of life and culture are at all what they should be: and if I ever see a piece of work from commercial sources which I should not have been ashamed to produce myself it is usually at a price which I should blush to ask for it.

5.3 Herbert Read: On Technical Education

5.3.1 From *Art and Industry* by Herbert Read, Faber & Faber, London 1934, 1945 edition pp 169–70

The critic Herbert Read (1893–1968) wrote widely on art and design in the first half of the twentieth century. His polemic *Art and Industry* described the previous 100 years as an attempt to impose irrelevant aesthetic values on to the products of machinery. Despite their emphasis on form rather than ornament, even Ruskin and Morris did not answer the problem as Read saw it. It was, 'not to adapt machine production to the aesthetic standards of handicraft, but to think out new aesthetic standards for new methods of production'. [3]

> *Art is regarded as something distinct from the process of machine production, something which must be taught as a distinct profession and then introduced into the processes of industry. Obviously, the factory itself must be the school of design. The whole notion of the artist as an intruder in the factory must be eradicated. If at the same time we abolish the notion of the artist as a separate entity, a separate individual, so much the better. The true kind of artist, the only kind of artist we want apart from the humanistic artist (painters of landscapes, portraits, modellers of war-memorials, etc.), is merely the workman with the best aptitude for design. That has always been clearly recognised in one industry – building, where we call the designer by the special name of* architect. *What we need is the recognition of the architect in every industry. Let us take as an example once again the simple case of the potter. The child who in his elementary school at Stoke or Burslem shows a talent for inventive design should not on that account be henceforth isolated and trained as if he were another Raphael; the chances are a million to one against his being a genius of that kind. He is just a good designer, and he should become a potter like his fellows. When he reaches the technical stage of education, he should still be trained as a potter. Good design, as we have seen, is governed by considerations of material, working, and function. All these are part of the technical process of potting. No teacher of art, admirable as he may be as a painter of landscapes or portraits, can teach the young potter anything essential to the mastering of design in the material of his craft. Only the experienced potter can teach him anything of value. There remains the question of ornament; people have some of their pots decorated – penny plain and twopenny coloured. But here again I have contended that the appropriate decoration is to be found in materials and technical processes. It was not an artist who discovered any of the forms of decoration typical of pottery before the middle of the eighteenth century, nor even of the best types of decoration typical of any pottery since that time; in every case it was the potter, working with the materials of his craft, and the tools of his craft. When the "pure" artist is brought in, then either he merely uses the surface of the pot as he would use the surface of canvas, and we judge the result as a painting and not as a pot; or he produces some abomination which has no relevance to the material or function of the pot. What is true for the simple industry of pottery is equally true of all industrial production of objects*

of use — of furniture, metalwork and textiles. Indeed, such is the paradox of the present position, that it is in industries where the artist as such never enters — the electrical industries, for example — that we find the best formal designs. This suggests that what we need more than anything is the total suppression of the professional art schools and colleges. Let us by all means continue to educate selected individuals to be painters of landscapes, portraits, modellers of war-memorials, etc. — though even here I believe by far the best system would be some system of apprenticeship in the studios of practising artists; but let all other forms of art instruction be assimilated to the Fachschule, or where these do not exist, to the factories themselves. The only alternative is to convert the schools into factories which is exactly what the Bauhaus was in Germany: a school with the complete productive capacities of the factory, an industrial system in minature. [...].

Education ... must be the basis of any adequate reform. But in the end we shall find that the fundamental factor in all these problems is a philosophy of life. The problem of good and bad art, of a right and wrong system of education, of a just and an unjust social structure, is one and the same problem. It is a problem which was posed in its clearest and unescapable terms by John Ruskin about a century ago. It is a problem which depends, as he so deeply realised, on a change of heart; and now, after two world wars and under an ever darkening cloud of adversity and error, we are perhaps a little nearer that necessary revolution.

5.4 On the Legacy of Morris and the Arts and Crafts Movement

5.4.1 From the Introduction by C. R. Ashbee to the catalogue (see Fig.16) of an Exhibition of Cotswold Art and Craftsmanship at Chipping Campden, [4] published privately, 1935, pp 3–5

What is the position of the crafts in our day? What indeed are the crafts? And what the relation of our Cotswold craftsmen to them? In answering some of these questions we might be tempted to pessimism if our outlook were limited to Campden and the Cotswolds, or even to England. But those of us who have studied the question practically, worked at the crafts with our hands, or given the best of our lives to them as designers, planners, organizers, and who observe what is going on in other parts of the world — in America, in South Africa, in Austria, in Germany, in Italy, in Hungary, in Scandinavia, and in the English colonies — know that we are ourselves part of a larger movement that has a very definite place in the new order.

The crafts are a protection against waste; they are an educational necessity; they are part of the community's leisure, and do themselves grow out of leisure; they are, in short, a great human need, and in a mechanistic age they take their place among the humanities. [...]

I don't think the form of craftsmanship much matters. Whether a man be an etcher or a thatcher, a blacksmith or a silversmith, a jeweller or a gardener is of little consequence; he may work in stone, in wood, in glass, in clay; what matters is that he works, and that he does his job well; for Art is doing the thing well.

5.4.2 From the Introduction by Eric Gill to the catalogue of an Exhibition of Cotswold Art and Craftsmanship at Chipping Campden and Cheltenham, published privately, 1936, pp 3–6

Eric Gill (1882–1940) attended classes in writing and illumination at the Central School of Arts and Crafts and devoted his life to the crafts. He is best remembered as a sculptor and letter carver working in London, Ditchling in Sussex, Capel-y-Ffin in Wales, and Piggotts in Buckinghamshire. He provided inspiration for many makers through his practical example and writings.

> *Disturbed by the groanings and creakings of the industrial system and the signs of its imminent collapse . . . we must recollect ourselves.*
>
> *Our world is too enamoured of its mechanical toys to surrender them . . . Moreover those who profit by their sale . . . are for ever proclaiming by the mouths of their tame philosophers that the process of human degradation cannot be stayed. They are fatalists, saying: What is must continue. But their world is not complete, and in the nature of things can never be. There will always be those who, nauseated by its self-worship, elect to go out. These, consciously or by implication, are they who, accepting the law that every man must work in order to live, know that man does not live for pleasure but for sanctification. And thus they accept what is necessary and make the necessary the Holy. But, to such an end, there must be personal ownership and control of the means of production, both material and technical. The bee-hive with its communal ownership and control and its destruction of operative freedom is directed towards "the leisure state" and the life of pleasure; but "the free man has joy in his labour and this is his portion".*
>
> *It has often happened that, in the stress of poverty, those who have thought to remain outside Babylon have found themselves frustrated. They holy thing which they desired has slipped from them, and they have found themselves to be no more than purveyors of a certain sort of sweetmeats beloved of the Babylonian suburbs. The arts and crafts became a commercial proposition. The craftsman became a lap-dog. We should beware of this futility. What we make, we must make with reason as well as with love. A certain asceticism is imposed upon us by our enforced eccentricity. Let us see to it that we imprint on matter "the mark of rational being".*

5.4.3 From *The English Tradition in Design* by John Gloag, Penguin, London 1946, pp 26–7

The architectural historian and writer John Gloag (1896–1981) was introduced to the DIA in 1924 and became a fervent advocate for good modern design. This well-illustrated book traces a line from medieval work through to the work of the contemporaries he admired including Sidney Barnsley, Gimson, Voysey, and Russell.

William Morris and those who helped him to revive handicrafts certainly opened the eyes of their fellow countrymen; but the effect of the Romantic movement and the First Industrial Revolution was still too strong for the English to see clearly. They were without critical standards. They respected the new enthusiasms for good workmanship; and they liked to think of 'hand-made' things; but the results were not gratifying to Morris, nor did they resurrect the English tradition in design. As a master-craftsman, he had during a third of a century edited the ideas of an England, so old, so out of tune with the turbulent enterprise and seemingly boundless prosperity of Victorian England, that he had, unintentionally, fostered a new respect for old things, based upon the romance of age not upon merit of design. Industry and trade catered for this new form of taste: metalwork was produced mechanically speckled with little dents to imitate hammer marks: woodwork was left with roughened surfaces: 'hand-made' became a sales story; and as people began to collect antiques, genuine and spurious, the dealer came into his own. The supply of antique furniture, china, pottery and metalwork was abundant in the late nineteenth century; many things of beauty had been consigned to lumber rooms and attics to make way for the Gothic preferences of Ruskin's disciples or for the richly ornamented and obviously comfortable things beloved by most true Victorians; but when genuine antiques began to run short early in the present century, a new occupation for craftsmen was discovered — their skill was used for copying old things and faking the evidence of age ... That debased industry was the worst by-product of Morris's great influence; it preserved an appearance of the English tradition, but like the embalmed corpse at an ancient Egyptian feast, it was without life. But the work of the artist-craftsmen who were originally inspired by Morris enjoyed a splendid vitality. It was partly through their individual skill that some lost threads of the English tradition of design were picked up.

Notes

1 Lincrusta walton was a material, originally made of linseed oil and cork dust, developed in the 1880s to produce low-relief wallpapers.

2 Alfred and Louise Powell worked as outside decorators for Josiah Wedgwood and Sons from 1903. Voysey also worked with established manufacturers designing furniture, wallpaper, textiles and metalwork. He would therefore have had some sympathy with the Powells's working relationship with the firm. Wedgwood provided the Powells with pottery blanks for decoration. Although Alfred Powell developed some new shapes they often used the standard wares. Voysey regularly criticised the qualities of smoothness and mechanical perfection that he found in much contemporary work, but the freshness and charm of the Powells's designs has the same appeal as many of his own two-dimensional designs.

3 Read, H. *Art and Industry*, 1945 edition, p.7.

4 Chipping Campden remained a centre for the Arts and Crafts after the collapse of the Guild of Handicraft. A local team including the etcher Fred Griggs (1876–1938), the ex-Guild wood carver, Alec Miller (1879–1961) and the stained glass artist Paul Woodroffe (1875–1954) began organizing annual exhibitions of art and craftwork in the 1920s which provided an important outlet for designers and makers. The catalogues provide a useful overview of the work being carried out in the area and usually included an essay on a related theme. They are a testimony to the richness and vitality of the Arts and Crafts tradition in rural England.

BIOGRAPHIES

Ashbee, C. R. (1863–1942)

Architect and designer who founded the Guild of Handicraft in 1888. He worked as an architect and planner in Egypt and Jerusalem from 1917–22 and was elected Master of the Art Workers' Guild in 1929.

Baillie Scott, M. H. (1865–1945)

Architect and designer who settled on the Isle of Man in 1889. He specialized in suburban houses and his designs with their decorative interior schemes were often featured in *The Studio*. He was commissioned to decorate the ducal palace at Darmstadt, Germany for the Grand Duke of Hesse; most of these designs were carried out by the Guild of Handicraft.

Barnsley, Sidney (1865–1926)

Architect, furniture designer and maker. He studied Byzantine architecture and was a member of Kenton and Company before moving to the Cotswolds with his brother, Ernest, and Gimson in 1893.

Benson, W. A. S. (1854–1924)

Trained as an architect before opening a workshop in London specialising in metalwork in 1880. He was closely linked with Morris and Company and became a director of the firm after Morris's death. He was also a founder member of the DIA.

Blomfield, Reginald (1856–1942)

Architect, designer and writer on garden design. He was a member of Kenton and Company and was appointed Professor of Architecture at the Royal Academy in 1906.

Clutton Brock, A. (1868–1924)

Essayist, critic and journalist who wrote a number of pamphlets and articles, particularly in *The Times*, promoting the work of the DIA.

Cobden-Sanderson, T. J. (1840–1922)

Writer and craftsman. Influential figure who trained as a lawyer but took up bookbinding. His Doves Bindery set a standard for Arts and Crafts bindings and he founded the Doves Press with Walker in 1902.

Coomaraswamy, Ananda (1877–1947)

Mineralogist, philosopher and writer of Sri Lankan and English parentage who was passionate about the crafts. He settled briefly in the village of Broad Campden, Gloucestershire in 1906 and lectured and wrote about the spiritual role of art and handicraft in Britain, the Indian sub-continent and the United States.

Crane, Walter (1845–1915)

Made his reputation as an illustrator of children's books but also designed textiles and wallpapers. He played an active part in the early years of the Arts Workers' Guild and the Arts and Crafts Exhibition Society and was elected Master of the Art Workers' Guild in 1888–9. His work was particularly influential in northern Europe and North America.

Davison, T. Raffles (1853–1937)

Architect and illustrator.

Day, Lewis F. (1845–1910)

A prolific writer on design and ornament and a freelance designer of textiles, wallpaper, carpets, tiles and furniture. In 1881 he was appointed Art Director of the textile manufacturer, Turnbull and Stockdale. He was elected Master of the Art Workers' Guild in 1897.

Fry, Roger (1866–1934)

Painter, art critic, and a leading figure in the Omega Workshops set up in 1913 to produce furniture, textiles, mosaic, stained glass and pottery designed by artists such as Fry, Duncan Grant and Vanessa Bell. They exhibited at the 1916 Arts and Crafts Exhibition and survived as a group until 1921. Fry was influenced both by the ideas of Morris and the Arts and Crafts Movement and contemporary art, particularly Cubism and Fauvism.

Geddes, Patrick (1854–1932)

Botanist and sociologist who promoted the Celtic revival in Edinburgh.

Gill, Eric (1882–1940)

Sculptor, letter carver and designer. He met Edward Johnston while he was a student at the Central School of Arts and Crafts and worked with him in London before moving to Ditchling, East Sussex in 1907. He moved to Capel-y-Ffin in Wales, and finally in 1928 to Piggotts in Buckinghamshire.

Gimson, Ernest (1864–1919)

Architect and designer of furniture, metalwork and plasterwork. He was a member of Kenton and Company before moving to the south Cotswolds with Sidney and Ernest Barnsley in 1893. He set up workshops with Ernest Barnsley at Daneway House in 1901, and took sole control in 1904.

Gleeson White, W. (1851–98)

Writer on handicrafts and design.

Gloag, John (1896–1981)

A prolific writer on architecture, social history and industrial design.

Green, A. Romney (1872–1945)

Gave up a career as a teacher of mathematics in 1900 to make furniture. He set up a number of workshops before settling in 1919 in Christchurch, Hampshire. He was inspired by Morris's ideas about art and life – like him Green was a poet and wrote about the crafts and social reform – and he combined all his interests to enrich his work.

Heal, Ambrose (1872–1959)

Served an apprenticeship with a cabinet maker before joining the family firm. He designed furniture for Heals from 1897 and was a founder member of the DIA.

Herbert, Albert (1867–1966)

Architect based in Leicester.

Horsley, Gerald (1862–1917)

Architect and illustrator who worked with both Shaw and Sedding.

Image, Selwyn (1849–1930)

Artist, illustrator, and member of the Century Guild who designed stained glass, embroideries and book bindings. He was elected Master of the Art Workers' Guild in 1900 and was a founder member of the Design and Industries Association.

Jackson, T. J. (1835–1924)

Architect and elected Master of the Art Workers' Guild in 1896.

Johnston, Edward (1872–1944)

Calligrapher. He established a tradition of Arts and Crafts calligraphy and graphic design both through his teaching at the Central School of Arts and Crafts and practical example.

Lethaby, W. R. (1857–1931)

Architect and designer of furniture and metalwork. He was a member of Kenton and Company but his main influence was as a writer and educationalist. He was involved with the Central School of Arts and Crafts from its foundation in 1896 and was sole Principal from 1900–12. He was elected Master of the Art Workers' Guild in 1911 and played an active part in the establishment of the DIA in 1915.

Liberty, A. Lasenby (1843–1917)

Manager of Farmer and Rogers' Oriental Warehouse in London before opening his own shop in Regent Street in 1875. Many Arts and Crafts designers worked for Liberty's including Voysey, Archibald Knox and Arthur Silver.

Macartney, Mervyn (1853–1932)

Architect, designer and member of Kenton and Company. He was elected Master of the Art Workers' Guild in 1899 and was editor of the *Architectural Review* from 1905–20.

Mackmurdo, A. H. (1851–1942)

Architect who set up the Century Guild in 1882. He designed furniture and textiles which were recognised as an inspiration for Art Nouveau.

McKenna, Ethel M. M. (fl. 1890–1905)

A member of the Guild of Women Bookbinders.

Morris, May (1862–1938)

Younger daughter of William Morris, she designed textiles, wallpaper and jewellery for Morris and Company and managed their embroidery workshop. She was a founder member of the Women's Guild of Arts in 1907.

Morris, William (1834–96)

Although he was best known to his contemporaries as a poet, Morris is best remembered as a designer, businessman and socialist. He wrote and lectured widely on art, handicraft and social issues. He was elected Master of the Art Workers' Guild in 1892.

Read, Herbert (1893–1968)

A critic who wrote widely on art and design.

Reeks, Maria E. (fl. 1884–1915)

Began working as an evening class assistant at the School of Art Woodworking in South Kensington and continued to teach at the school until 1915. She was appointed manager of the school in 1902.

Rowley, Charles (1840–1933)

Writer and art dealer who also made frames for a number of artists. He was a councillor in Manchester, a philanthropist and founder of the Ancoats Brotherhood which made art and literature available to the working classes.

Russell, Gordon (1892–1980)

Designer, businessman and arts administrator. Worked for his father's firm, Russell and Sons, and began designing furniture in 1921. He also designed metalwork and glassware. During the Second World War he joined the Utility Furniture Advisory Committee and in 1947 was appointed Director of the Council of Industrial Design.

Sedding, John D. (1838–91)

Ecclesiastical architect and designer whose London practice nurtured many of the leading figures in Arts and Crafts Movement. He was elected Master of the Art Workers' Guild in 1886–7.

Shaw, R. Norman (1831–1912)

Architect whose practice was as influential as that of Sedding. He developed his interpretation of the Queen Anne style building large country houses but his most influential work was the smaller scale development at Bedford Park, west London in the late 1870s.

Sparrow, W. Shaw (fl. 1890–1926)

Writer on art, architecture and design.

Troup, Francis (1859–1941)

Architect. He commissioned furniture from Gimson and collaborated with him over some designs. He built the hall at Queen's Square, London for the Art Workers' Guild and was elected its Master in 1923.

Voysey, C. F. A. (1857–1941)

Architect whose ideas were influenced by his religious beliefs. His furniture and two-dimensional designs for textiles and wallpaper were particularly influential. He was elected Master of the Art Workers' Guild in 1924.

Waals, Peter (1870–1937)

Furniture maker and designer. Originally from Holland, Waals worked as Gimson's foreman from 1901 and set up his own workshop at Chalford, Gloucestershire in 1919.

Walker, Emery (1851–1933)

A process engraver who worked closely with Morris in setting up the Kelmscott Press, which inspired the twentieth-century Private Press movement. He founded the Doves Press with Cobden-Sanderson in 1902 and was elected Master of the Art Workers' Guild in 1904.

Webb, Philip (1831–1915)

Architect and designer. He designed the Red House for Morris and a number of other country houses decorated by Morris and Company including Standen, near East Grinstead. He also designed furniture, glass, stained glass and metalwork for the firm.

Webb, Stephen (1849–1933)

Designer of furniture for Collinson and Lock specialising in intarsia or inlaid work in ivory and wallpaper for Jeffrey and Co. He later taught sculpture at the Royal College of Art.

Wells, Percy A. (fl. 1909–34)

Head of Cabinet Making at the LCC Shoreditch Technical Institute. He wrote a number of practical books on furniture design and making.

Wilde, Oscar (1855–1900)

Writer and playwright. He lectured on art and design in Britain and America in the 1880s.

Willink, W. E.

Liverpool architect and member of the firm Willink, and Thinknesse, which built the Cunard Building on Liverpool's Pier Head.

Wilson, Henry (1864–1934)

Influential architect who took over Sedding's practice. He was the first editor of the *Architectural Review* from 1896–1901. He also designed metalwork and jewellery and taught metalwork at the Central School of Arts and Crafts. He was elected Master of the Art Workers' Guild in 1917.

SELECT BIBLIOGRAPHY

Arts and Crafts Exhibition Society, *Arts and Crafts Essays*, London 1893, reprinted with an introduction by P. Faulkner, Thoemmes Press, Bristol 1996.

Ashbee, F. *Janet Ashbee: Love, Marriage and the Arts and Crafts Movement*, Syracuse University Press, Syracuse, 2002.

Backemeyer, S. and Gronberg, T. (eds) W. R. Lethaby 1857–1931: *Architecture, Design and Education*, Lund Humphries Publishing, London 1984.

Callen, A., *Angel in the Studio: Women in the Arts and Crafts Movement 1870–1914*, Astragal Books, London 1979.

Carruthers, A. and Greensted, M. (eds) *Simplicity and Splendour, Arts and Crafts Living: Objects from the Cheltenham Collections*, Lund Humphries Publishing, London 1999.

Carruthers, A. and Greensted, M. *Good Citizen's Furniture: The Arts and Crafts Collections at Cheltenham*, Lund Humphries Publishing, London 1994.

Carruthers, A. *Ernest Gimson and the Cotswold Group of Craftsmen*, Leicestershire Museums, Leicester 1978.

Cobden-Sanderson, T. J. *The Arts and Crafts Movement*, Doves Press, London 1905.

Comino, M. *Gimson and the Barnsleys: 'Wonderful furniture of a commonplace kind'*, Evans Brothers, London 1980 (and Sutton Publishing, Stroud 1991 as M. Greensted).

Crane, W. *William Morris to Whistler*, G. Bell & Sons, London 1911.

Crawford, A. C. R. *Ashbee: Architect, Designer and Romantic Socialist*, Yale University Press, New Haven and London 1985.

Crawford, A. (ed.) *By Hammer and Hand: The Arts and Crafts Movement in Birmingham*, Birmingham Museums, Birmingham 1984.

Cumming, E. and Kaplan, W. *The Arts and Crafts Movement*, Thames & Hudson, London 1991.

Davey, P. *Arts and Crafts Architecture*, Architectural Press, London 1981.

Drury, M. *Wandering Architects*, Shaun Tyas, Stamford 2000.

Goodden, S. *A History of Heals*, Heal & Son Ltd, London 1984.

Greensted, M. and Wilson, S. (eds) *Originality and Initiative: the Arts and Crafts Archives at Cheltenham*, Lund Humphries Publishing, London 2003.

Harvey, C. and Press, J. *William Morris, Design and Enterprise in Victorian Britain*, Manchester University Press, Manchester and New York, 1983.

Howes, J. (ed.) *Craft History One: Celebrating the Centenary of the Arts and Crafts Exhibition Society*, Combined Arts, Bath 1888.

Jewson, N. *By Chance I Did Rove*, published privately 1951, 2nd edition published privately 1973, 3rd edition Barnsley, Gloucestershire 1986.

Kaplan, W. *The Arts & Crafts Movement in Europe and America*, Thames & Hudson, Los Angeles and New York 2004.

Kirkham, P. *Harry Peach, Dryad and the DIA*, Design Council, London 1986.

Kuzmanovic, N. N. John *Paul Cooper: Designer and Craftsman of the Arts and Crafts Movement*, Sutton Publishing, Stroud 1999.

Lambourne, L. *Utopian Craftsmen*, Astragal Books, London 1980.

Lethaby, W. R., Powell, A. H. and Griggs, F. L. *Ernest Gimson: His Life & Work*, Shakespeare Head Press, Stratford-upon-Avon 1924.

Lethaby, W. R. *Phillip Webb and His Work*, Oxford University Press, London 1925.

MacCarthy, F., *All Things Bright and Beautiful: Design in Britain 1830 to Today*, George Allen & Unwin, London 1972.

MacCarthy, F. *The Simple Life: C. R. Ashbee in the Cotswolds*, Lund Humphries Publishing, London 1981.

MacCarthy, F. *William Morris*, Faber & Faber, London 1994.

Mackmurdo, A. H. (ed.) *Plain Handicrafts*, Percival and Company, London 1892.

Myerson, J. *Gordon Russell: Designer of Furniture*, Design Council, London 1992.

Naylor, G. *The Arts and Crafts Movement*, Studio Vista, London 1971.

Naylor, G. (ed.) *William Morris by Himself: Designs and Writings*, Macdonald & Co., London 1988.

Parry, L. *Textiles of the Arts and Crafts Movement*, Thames & Hudson, London 1990.

Parry, L. (ed.) *William Morris*, V & A Publications, London 1996.

Poulson, C. (ed.) *William Morris on Art and Design*, Sheffield Academic Press, Sheffield 1996.

Richardson, M. *Architects of the Arts and Crafts Movement*, Trefoil Books, London 1983.

Tanner, R. (ed.) *The Turn of the Century, extracts from the diaries of Dorothy Walker: 1899, 1900, 1901*, published privately Llandogo 1995.

INDEX